QUESTION BRIDGE

BRIDGE

BLACK MALES IN AMERICA

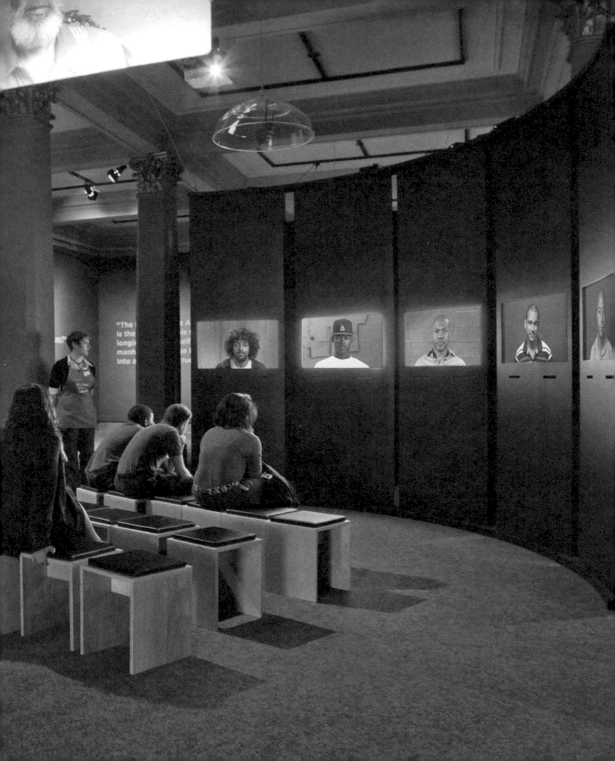

QUESTION BRIDGE

BRIDGE

BLACK MALES IN AMERICA

EDITED BY Deborah Willis & Natasha L. Logan

FOREWORD BY Ambassador Andrew Young
PREFACE BY Jesse Williams

FEATURING CONTRIBUTIONS BY Chris Johnson, Hank Willis Thomas,
Bayeté Ross Smith, Kamal Sinclair, Delroy Lindo, and Rashid Shabazz

aperture

EDITORS' NOTE

The content in the chapters (pp. 24–235) was originally recorded between 2008 and 2011. Questions and responses have been excerpted from their original format, as spoken by the participants and featured in the original *Question Bridge: Black Males* video art installation. This project would not have been possible without the participation of all the men who were recorded in Atlanta; Birmingham, Alabama; Chicago; Philadelphia; New Orleans; New York; Miami; Oakland, California; San Bruno County Jail, California; and San Francisco:

Dwayne H. Adams, Sr., Vonteak Lee Alexander, Gavin J. Armour, Carl E. Bailey, Christopher Ball, Terrence Battiste, Corey Baylor, Adler Bernard, Mickyel Bethune, Tony Bingham, Stephen Bradberry, Morris Brent, Christopher Briellard, Clarence Brooks, Joel Brown, Rodney Brown, Tony Brown, MD, John Hope Bryant, William Bunn III, Keith Calhoun, Michael I. Chambers, Shaun Chapital, Rich Cockrell, Lester N. Coney, Ralph Cook, Bryan Michael Cox, Mark Cox, Yaakov Curry, Tyrone Dangerfield, Gabriel Daste, Keunthi Davis, Dr. Howard Dodson, Bill Doggett, Jermayue C. Edwards, Robert Edwards, Lolis Eric Elie, Clifton Faust, Richard Findley, Omarr Flood, Frederic Frierson, Nelson George, Tyuan Glover, Michael Goines, Robert Gore, MD, Lonnie Graham, Frank Greene, Abel Habtegeorgis, George M. Hagan, Michael Harris, Thomas Allen Harris, Musa Hixson, Charles Hollins, John Kingsley Holton, Marquez Hood, Robert "Kool Black" Horton, Robert Humphery, E. Patrick Johnson, Jamal Johnson, Kevin A. Johnson, Waldo E. Johnson, Jr., PhD, Darrale Jones, Derek A. Jones, Melvin Joseph, Abdul Karim, Coby Kennedy, Kenny Kent, Saddi Khali, Andalib Khelghati, William Kindricks, Yashua Klos, Anansi Knowbody,

Corey D. Lawrence, Sean Leake, David Lemieux, Mike Levin, Unity Lewis, Michael Liburd, Tillman-Curtis Liggins, Dennis Light, Delroy Lindo, Kalup Linzy, Jabari Mahiri, Faheem Majeed, Nathaniel Manning, Kenneth Marshall, Reverend Warren Marshall, Majic Massey, Isaiah McCormick, Armani McFarland, Dr. Dwight McKenna, Eric McNeal, Ivan Montgomery, Alex Morgan, Edward Morris, Yusufu Mosley, Girard Mouton III, Johnnie Muhammad, Djuan Muldrew, Christopher Myers, Jumaane N'Namdi, Darryl Norton, Julian O'Connor, Reverend C. Herbert Oliver, Chandler Parker, DeMario Patton, Eternal Polk, Ronald Porter, Jonathan Poullard, Robert E. Proctor II, Reverend James Quincy, Guthrie Ramsey, Mike "Killer Mike" Render, Ethan Richards, Will Roberson, Julian T. Roberts, Edward D. Robinson, Jr., Michael Robinson, Malik Seneferu, Jamel Shabazz, Michael Shannon, Danny Simmons, Darran Simon, Jeff Sims, Gerald Sinclair, Elijah Smith, Ike Smith, Melvin Smith, Tony Snow, Gregory A. Stanton, Roderick Tannehill, Minister Server Tavares, Kelsey Taylor, Greg Thompson, Anthony Trochez, Dr. Jamu Wayne Tukes, Eugene Varnado II, Kenneth Varner, Jr., Anthony Vaughn, Marcel Waldron, Reginald Watson, Richard J. Watson, Dr. Kyshun Webster, Jermaine White, Rasheed Wilds, Chris Williams, Jesse Williams, Patrick Williams, Cecil Willis, Brian J. Winzer, Larry Witherspoon, Josiah Yoba, Malik Yoba, and Ambassador Andrew Young.

The artists have made all of the original content available online. To listen to these questions and more, go to www.questionbridge.com or download the mobile app from the Apple Store or Google Play Store.

—Deborah Willis and Natasha L. Logan

CONTENTS

FOREWORD

BY AMBASSADOR ANDREW YOUNG

Thinking about the concept of advocacy for black men and boys,
I am reminded of just how long this issue has frayed the fabric
of America. To wit, consider these remarks taken from the speech
"The Nation's Problem" by Frederick Douglass, delivered at an event
in Washington, D.C., in 1889, marking the twenty-seventh anniversary
of the abolition of slavery.

> Mark, if you please, the fact, for it is a fact, an ominous fact, that at
> no time in the history of conflict between slavery and freedom in
> this country has the character of the Negro as a man been made the
> subject of a fiercer and more serious discussion in all the avenues
> of debate than during the past and present year . . . The American
> people have this lesson to learn, that where justice is denied, where
> poverty is enforced, where ignorance prevails, and where any one
> class is made to feel that society is an organized conspiracy to
> oppress, rob, and degrade them, neither persons nor property would
> be safe.

Those words resonate appositely with us today even though we are
more than 150 years removed from the issuance of the Emancipation
Proclamation. As long as our country continues to be beleaguered
by painful injustices, disparate opportunities, and brazen intolerance
against black males, we will be a nation divided.

Installation view, courtesy the Oakland Museum of California, 2012. Photograph by Yoni Klein

Just over twenty years ago, the W. K. Kellogg Foundation expressed interest in convening a diverse group of black leaders who had intimate knowledge and awareness of the specific challenges African American men and boys face. In 1992, with the express mission to address the issues confronted by this demographic and seek redress through a holistic approach to empowerment, the Foundation held a national conference in Washington, D.C., comprised of forty-seven grassroots and community leaders who had special interests and engagement with African American men and boys. This meeting of professional, spiritual, and scholarly minds led to the establishment of the National Task Force on African-American Men and Boys, which I chaired. Our mission stated:

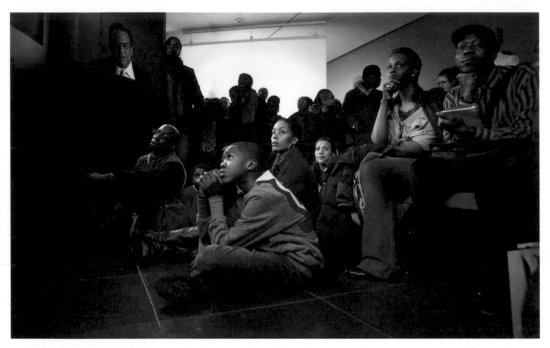

Installation view at the Brooklyn Museum, 2012. Photograph by Yosra El-Essawy

> The purpose of the Task Force is to provide ideas that organizations
> and individuals can use to transform communities, thereby assisting
> families and boys. Always in the forefront is the desire to create a
> long-term structure for sustained intervention for boys who are in
> trouble. The emphasis is on systemic change that will bring together
> a multiplicity of ideas to reduce violence and crime, and make
> America's social life whole again.

We saw that broken communities, places of social, economic, and
physical distress, opened the door to depressed potential, unhealthy
behaviors, helplessness, and hopelessness, thus inviting crime
and violence. We knew, as reapers of the harvest of seeds sown
by the blood, sweat, and sacrifice of our forefathers, that we had
a responsibility to pass on our blessings to our brothers who were
falling through the cracks, and those who were at risk. We needed
to be repairers of the breach. It says in Isaiah,

Then you shall call and the Lord shall answer, you shall cry and
He will say, Here I am. If you take away from the midst of you the
yoke, the pointing of the finger, and speaking wickedness. If you pour
yourself out for the hungry and satisfy the desire of the afflicted, then
shall your light rise in darkness and your gloom shall be as noon day,
and the Lord will continually guide you and satisfy your desire with
good things. You shall be like a water garden, like a spring of water
whose waters fail not, and your ancient ruins shall be rebuilt. You
shall raise up the foundations of many generations and you shall be
called the repairer of the breach, the restorer of streets to dwell in.

The Task Force went to work. We did the research and looked for
solutions. We wanted to make America whole by helping to fill the
gaps in opportunity so often faced by black men and boys. We saw
that talent, potential, and possibilities went largely untapped because
of deprivation and despair. We saw safe, sound, thriving communities
as the foundation for enabling and realizing human potential. We
wanted to restore the streets so man, woman, and child could dwell in
a healthy society, and discover their purposes. We made a plan.

Two years later, the National Task Force on African-American
Men and Boys convened again, delivering the groundbreaking report
*Repairing the Breach: Key Ways to Support Family Life, Reclaim Our
Streets and Rebuild Civil Society in America's Communities* (1996).
It was an unprecedented convention of ideas laid bare to address our
ills as a race, and conflated by "the Nation's problem."

In 2014, I served as one of the keynote speakers for a conference
commemorating the twentieth anniversary of that groundbreaking
report. The Harvard University Graduate School of Education's
Dean's Advisory Committee on Equity and Diversity joined with the
Morehouse Research Institute and Dr. Bobby William Austin, the
developer of the initiative and editor of the report, to invite students,
policy makers, educators, activists, and philanthropists to spend a
day reflecting on the significance of the task force and the lessons
learned, discuss the status quo, and forge relationships.

I remember walking into one of the rooms during the conference

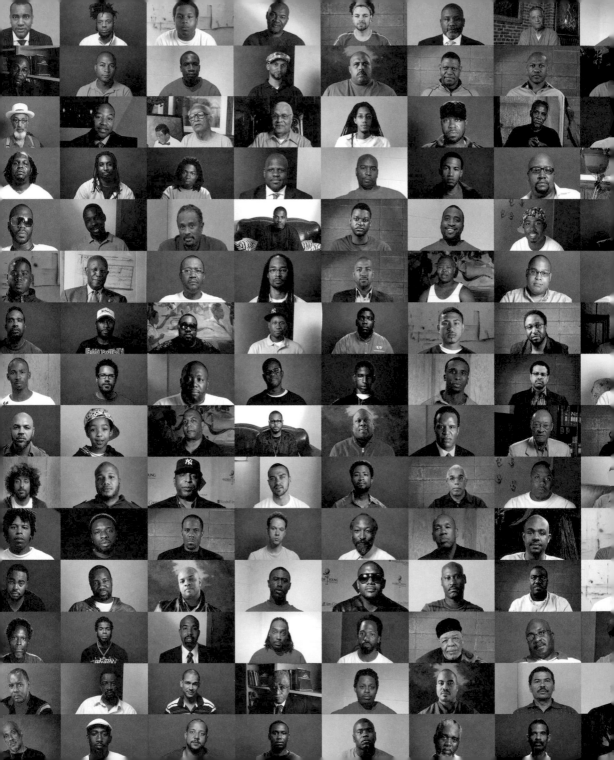

and seeing an image of Thurgood Marshall on the big screen with the quote: "None of us got where we are solely by pulling ourselves up by our bootstraps. We got here because somebody—a parent, a teacher, an Ivy League crony, or a few nuns—bent down and helped us pick up our boots."

The notion of mentoring black men and boys has been a fact of our lives since slavery, through Reconstruction, the civil rights movement, and now through the historic election of an African American president and the founding of his White House initiative, My Brother's Keeper.

None of us got here alone, not without being inspired, empowered, and enlightened by other men.

Question Bridge is keeping up that proud tradition through innovative engagement and virtual mentoring. Though the dialogue uses twenty-first-century communication, technology, and digital media, the purpose, concept, and value remain the same as they were when the only way you could communicate with someone was if they were sitting right in front of you. Because of *Question Bridge*, more stories can be told, and more people can be reached.

More than anything, though we can provide the vehicles—meeting at conferences and creating opportunities—black men and boys, or anyone, for that matter, must believe in themselves first. They must believe that God put them on this earth for a purpose, and that they're really not alone.

One of my favorite hymns says, "Earth has no sorrow that heaven cannot heal." That's my faith. I'm old enough to have been through "many dangers, toils and snares," and I've always come through by God's amazing grace. So I have no fear of the future, because I don't know what the future holds. But I know who holds the future. I take one day at a time, confident that if we are responsible and faithful, there is no problem we can't solve.

Men and women of means and maturity must reach down, reach back, and reach out, and lend a hand to help pull our brothers and sisters out of the breach of despair. Each one should teach one. It's our moral imperative.

PREFACE

BY JESSE WILLIAMS

Question Bridge arrived at a pivotal point in my life. I'd just moved from Brooklyn to Los Angeles, switched careers and found a new community. My previous job as a public high school teacher had been the most demanding and rewarding position I'd ever held. When executed effectively, it's one of great service. Waking up a few short years later on the set of a television show instead of in a classroom brought with it new charms, but left a considerable void in my sense of purpose. Not only did joining forces with *Question Bridge* help me carve a path back to center, it enlightened and empowered me to impact American media output. *Question Bridge: Black Males*, as it was originally known, allows the public to engage with, explore, and lift up the incredibly diverse panoply that is black American life.

 As an American consumer, existing within wildly different communities, I grew up well aware of the disparity between the media's narrow, redundant representation of blackness and the realities surrounding me. But suddenly I'd gained backstage access in Hollywood, with an increasingly unobstructed line of sight toward the machinations that projected and informed American racial dynamics. It didn't take long to appreciate the severity of this connection or the futility of relying on Hollywood to change itself. *Question Bridge* is a declaration that we will no longer wait and beg and hope for screens to portray black males in a diverse and occasionally positive light.

We will do that ourselves, without studios, writers, or actors, for we need only our authentic selves and a hunger to be heard.

My colleagues formed *Question Bridge* as an act of leadership and resistance, putting us on offense while maintaining an active and creative defense. Our ability to see the humanity in those around us is absolutely critical to any potential progress related to social justice and racial coexistence. This never fails to demonstrate its importance at our *Question Bridge* installations around the country—watching, for example, a group of middle-aged white women exit a screening together in tears, astonished by the humanity they'd just witnessed from black men who, they admit, they routinely steel themselves against in public. "Some of those men were just like my son, or my husband," one woman said. Such a discovery can provide both great relief and insult, but the fact is, there's a significant segment of the population—a politically powerful and valued segment—that is simply starved of the tools required to truly see, acknowledge, and relate to black humanity on its own terms.

As bleak as that may sound, we're part of a movement to change that. Collecting and sharing the radical diversity within the black male population alone will positively impact policy and the electorate's interest in exploring issues that are healthy instead of hurtful for black and brown Americans. Our work can make two crucial strides simultaneously. It can hold a mirror up for black Americans to see the vivid range of possibilities in and around them, and reignite the interests and pursuits necessary for success and survival. And for the generally underexposed or uninterested white American population, *Question Bridge* can smash the very stereotypes, stigmas, and other limitations of the imagination that persistently erect cages between and around certain groups.

Please continue to support and challenge us at *Question Bridge*, and each other. As we approach our modest black male participant goal, we couldn't be more excited about expanding the platform to include a range of fascinating inter- and intra-demographic dialogues. Here's to a creative future, together.

INTRODUCTION

BY CHRIS JOHNSON

> The teacher is of course an artist, but being an artist does not mean
> that he or she can make the profile, can shape the students. What
> the educator does in teaching is make it possible for the students
> to become themselves.

—PAULO FREIRE
From *We Make the Road by Walking:*
Conversations on Education and Social Change (1990)

What does it mean to ask a question? I remember when I first
realized just how much the simple act of asking a question reveals
about the questioner, especially if the question is a deeply personal
and meaningful one. It's an active form of generosity to look into
your life to discover and then reveal an uncertainty, a lack of
understanding about yourself or the world. This can be compared to
the more passively generous act of listening, something highly valued
these days. But if the question is a sincere one, the questioner is
preparing him or herself to listen to the answer. On the one side is a
person who has discovered and is sharing his or her unknowing, and
on the other is someone who may have an answer that the questioner
is prepared to hear.

It seems simple, but none of this can happen if the questioner
does not feel safe enough to acknowledge and express what he or she

lacks and needs to know. When the process works, what has been created might be called a question bridge.

All of these were dormant and abstract ideas for me before I met Suzanne Lacy, a well-known performance artist and writer. Suzanne came to the California College of the Arts, where I teach as a dean of fine arts, and recruited me into a collaboration that resulted in a project called *The Roof Is on Fire* in 1994.

The goal of this project was to make it possible for marginalized young people of color to express themselves freely and be heard by people who ordinarily would not be inclined to take these kids seriously. What we did was put hundreds of ethnically diverse young people in cars on the upper floors of a parking garage in downtown Oakland, and put badges around their necks that read, "Shut Up and Listen!" The idea was that this theatrical setting would help the kids feel safe enough to talk openly about all of the personal and meaningful themes of their lives—things like their fears and how it felt to be stigmatized—and know that they were being heard by the audience of eavesdroppers gathering around the cars.

Oakland's socioeconomic landscape is largely divided between the middle and upper classes in the surrounding hills and working-class communities in the flatlands below. It was inspiring to see people from the hills being offered a rare glimpse into the way these young people really feel. The project proved to be a great success and, with the help of a good friend, Annice Jacoby, *The Roof Is on Fire* made a small name for itself. After a long career as a fine-art photographer, I had become known as a socially engaged performance artist. This is how things stood in my life when an unexpected and decisive opportunity came my way.

Arthur Ollman, a dear friend who was then director of the Museum of Photographic Arts in San Diego, recommended me to a curator named Richard Bolton who was looking for artists to create a faux newsroom in the museum, to coincide with the 1996 Republican National Convention. Richard asked me if I would consider creating a video installation piece that reflected my current interests. With some trepidation, I agreed. I had never worked in video before, but

Chris Johnson, video stills from the original *Question Bridge* project, San Diego, 1996

as I spent days running various ideas through my mind, it suddenly occurred to me that there might be a significant way to connect the process of working with video to a powerful experience from my childhood.

I spent most of my early life living in the Bedford-Stuyvesant section of Brooklyn. In the 1950s and early '60s, before the passage of the civil-rights-era Fair Housing Act, African Americans faced discriminatory restrictions on where they could buy or rent property. Because of these limitations, the neighborhoods where I grew up were a mixture of black families of all classes, professions, and occupations. I remember black doctors and lawyers who lived only a few blocks away, and there were many white-owned businesses nearby that served them. But I also remember how shocking it was to see how quickly both these professional-class black families, and the white-owned businesses, disappeared as soon as the legal climate changed. It was a dramatic and troubling experience. Suddenly there was a sense of being left behind; storefronts were now shuttered with steel curtains at night. African Americans of all types were faced with a choice of whether or not they could, or even wanted, to leave the familiar sites of community we had known, to cross rivers and divide the black community geographically, just as is now true in most parts of the country, This was a powerful early experience and

I believe that the more art draws on the mystery of such experience, and translates it, the more relevant, nuanced, and meaningful artworks become.

In the early 1990s, social commentators like comedian Bill Cosby were making an issue of the divide between African Americans who lived within mainstream American culture and those whose lives and values and language and aspirations were focused on what we call "the hood." I was vividly aware of how separate these two factions of the greater African American community had become, and it occurred to me that there might be a place within this complex issue to use questions as a form of social and cultural bridge-building. What if I used the relative safety of being videotaped at home as a way of bringing up questions that these two cultures of black people had for each other? What if I said to people I recruited from both sides of this cultural divide, "Look into the camera and imagine that you are seeing someone who is living a life very different from your own. Now ask them a question that you have always wanted answered?" What if I simply played the videotape of that person asking a sincere question to someone on the other side, and taped their spontaneous answer to that question?

I could then edit these questions and answers together into a simulated conversation between these two people who might never meet face-to-face. The result would be a moving and revealing question bridge that would contain the legitimate voices of people who, from the outside, would appear to belong to each other, but who in fact were radically divided. I remember precisely where I was when I said to myself, "Now that might work!" And I remember how exciting and challenging it was to begin putting all the pieces in place to make that first version of *Question Bridge* possible. I had to learn how to use a video camera, find an assistant, and, most important, recruit people on either side of the cultural divide who were willing to work with me. That proved to be a very easy thing to do.

Everywhere I went in San Diego, I found African Americans who were more than willing to respond when I asked them if they had questions they had always wanted to ask blacks who lived a different

lifestyle. The now-classic example was when Keyona Johnson looked into my camera and asked the person she was imagining, "Why is it that African American males or females, when looking for employment or higher status in life, must act as white as you possibly can, talk as white as you possibly can, look as white as you possibly can, and fit in with the whites as you possibly can? Why is that?" On the other side, William Gaines asked, "Have you given any thought to where the money for public assistance comes from, and do you care?"

While it's not surprising that people would have these sharp and penetrating questions for each other, I have to admit that it was a continuing surprise to hear how prepared they all were to provide direct answers. Over time I came to understand that marginalized people move through the world under a cloud of questions that are always, covertly, being asked of them. "How do you expect to get a decent job with your teeth full of gold?" Or, "Don't you know the prison origins of low-slung pants, and don't you care?" All that *Question Bridge* is doing is giving them a chance to express answers they have been silently rehearsing all their lives.

That original *Question Bridge* was powerful and meaningful, but it would have been lost to memory were it not for Hank Willis Thomas. Hank came to CCA as a graduate student and has gone on to a very notable career as a fine artist. I must have mentioned the 1996 version of *Question Bridge* to him at school. As fate would have it, one day he was helping his mother, the distinguished artist, scholar, writer, and curator Deborah Willis, clean out her VHS collection, and he came across a copy I had sent her years before. When Hank called me with the idea of creating a new version of the project, he persuasively argued for two variations that proved to be essential. He knew that I was committed to creating *Question Bridge* projects within rather than between demographic groups. It seems to me that inter-demographic conversations are fairly predictable at this point. Hank's idea was that this new *Question Bridge* project should be done exclusively with black males rather than across all black Americans.

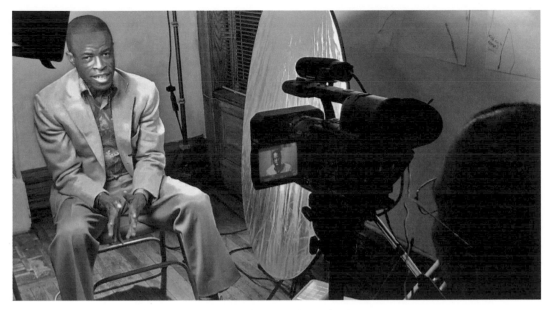

Chris Johnson filming Waldo E. Johnson, Jr., Chicago, 2011. Photograph by Hank Willis Thomas

His point was that black men differ from each other in such significant ways that this project would give us a chance to show the spectrum of black male consciousness. This proved to be a brilliant truth. Hank's second point was that we should not predetermine what it is that these men would consider dividing issues. He said that all we should do is ask the men to offer a question they have always wanted to ask another black man who they feel is very different from themselves. And, once again, he was exactly right.

What this innovation allowed the men to do is personalize their questions and answers, and it gave the project a range and depth that it wouldn't have otherwise had. Hank recruited one of his longtime friends, Bayeté Ross Smith, to help us, and so, having raised the money necessary to start, the three of us set off for Birmingham, Alabama, in 2007 to begin the process of creating *Question Bridge*. Along the way, writer and performance artist Kamal Sinclair joined our team, bringing a wealth of talent and business acumen to what evolved into a truly collaborative process.

At a certain point I'm sure that all of us began to wonder if we just happened to have stumbled upon an unusually articulate group of men, or if we were learning something more significant about the essential nature of black men, and men in general, from this project. The tone and spirit of the questions and answers we gathered so often signified deep and troubling concerns that black men have about the state of their place both within themselves and within our culture. Over and over, we found that the men we met were expressing confusion, frustration, challenges, and remedies they wanted to offer for the pain being shared with us, even when tinged with humor.

"Am I the only one who avoids eating watermelon, bananas, and fried chicken in front of white people?" one participant asked. The answers were clear: "No, you are not the only one!" Far too many of us continue to struggle with the projected shame of slavery.

One iconic question came after Bayeté and I went exploring in Algiers, at that moment a rain-soaked community across the Mississippi from New Orleans. In a small but lively black church we encountered Anthony Vaughn, a young man with a beautiful dark face and perfect dreadlocks who, when we met him, was standing next to a deacon with a Bible in his hands. He showed up the next day at our impromptu studio in the Ninth Ward, and after I got him well-lit and focused, he looked into the camera and said, "I try to live good, but I'm surrounded by bad. I want to know what it is I can do to do better and live peaceful, surrounded by all evil. How can I do that?" Seeking a meaningful answer to that question, as it applies to all of us, has been one of our missions since that moment.

But there is another reality that came immediately to light in the Question Bridge project: that black male consciousness is not only a source of questions and concerns, but also a fertile source of answers, strength, and compassion. These men care very deeply about each other and were spontaneously more than willing to offer up advice, wisdom, and support. In its own way this project makes clear just how far we have come as a family, and how far we still need to go.

One of the team's most important goals is that this project will inspire more positive ways for black men to see themselves, each other, and how they are perceived by the world. We know that our family will make its way forward just as others before us have: one generation at a time.

QUESTION BRIDGE

IDENTITY

BLACK MALES IN AMERICA

RICHARD J. WATSON

Q:

MY QUESTION TO THE
BLACK MAN IN AMERICA,
OR ANYWHERE, IS: WHAT
IS COMMON TO ALL OF US
THAT WE CAN SAY MAKES
US WHO WE ARE?

Rich Cockrell

I like that hat. I think what makes us more common is, first of all, we're all black. And I think the second thing that makes us common is we're all black, and the third thing that makes us common is we're all black. Now, in our blackness we have struggles that parallel one another's.

Reverend C. Herbert Oliver

There is one thing that African American men all have in common, and that is the perception of them by the white community. That perception is that you are not a man, you are less than a man, at most you are three-fifths of a man, and you are not fully to be respected. You have no rights that are to be respected in the dominant white society.

Tyrone Dangerfield

What is common that makes us who we are, that's universal, is our strength. Our inner strength. It doesn't seem like that sometimes, but it is. For centuries, the black man has been used to being beat down. But he keeps rising, keeps coming back strong. It's like a superhero in a comic book.

Abel Habtegeorgis

One thing I've found to be common amongst all black men is our walk, to be quite honest. The way we walk down the street, you know it's a strong black man. That walk is confident, it's strong, it's swagger, and it has style.

Delroy Lindo

That's a really, really interesting question. I mean that's a profound question. And I think, because we are not monolithic, that the thing that we have in common—and I'm not being facetious when I say this—the thing that we have in common is that we are male, and we are black.

Guthrie Ramsey

I could never assume that just because we look the same, I would have more in common with you than not. That is really, on the personal level, I think it's really a misconception that if you have a group of black men in a room that they will have more commonalities than differences.

Julian T. Roberts

Unfortunately, what's most common is probably our miseducation and misconception of who we are.

Ronald Porter

I don't want to answer this in a way where I'm going to claim some sort of monolithic black-man community, and we have something common to us all. For me, speaking personally, the commonality resides in the fact that I come from a very strong and rich tradition that has resisted racism in this country, and has celebrated life. However, there are many, many, many things that make us different, and I think those things should be celebrated. They shouldn't be disparaged and they should be acknowledged. So our commonality is in our history, but I think our beauty is also in our diversity.

JOSIAH YOBA

Q:

I HAVE A QUESTION:
HOW DO YOU KNOW WHEN
YOU BECOME A MAN?

Gregory A. Stanton

Wow, that's a deep question for such a young person! How do you know when you become a man? Well, basically, responsibility. You're able to take on, assume, responsibility. Hold fast to your commitments to yourself first, your family, and the community in which you live. If you can do those things, then you're on the way to manhood.

Julian T. Roberts

The question of when you become a man . . . you're born a man. When you come of age may be a more relevant question, but some of us come of age many, many, many times throughout the course of our lives. I thought I was a man at twenty-one, ready to write memoirs of all my experiences. I don't know how many times I thought I knew the answer to everything, and I'm here again, thinking that I know it all. But you'll know.

David Lemieux

Oh, that's a fine question there. I think one of the mistakes we often make is thinking that the first time we're intimate with a woman, now we're a man. In traditional societies, in order for boys to go into manhood, they had to go through certain rituals, which prepared them to fit whatever role they had in that society.

Yusufu Mosley

Young brother, I knew I became a man when I had to take on certain responsibilities and obligations to family, community, and otherwise.

E. Patrick Johnson

I think sometimes I still try to answer that question, whether I've become a man. I grew up in a single-family home without a father, but I'm the youngest of seven, and I have six older brothers who taught me about being a man. And part of that is trying to be responsible to my family, and to my loved ones, and being a responsible citizen. But I think each of us needs to find our own way to that path of what it means to be a man.

Tillman-Curtis Liggins

Young'un. Young'un. Whoo.

I'm still trying to figure that out myself. It's tough, it's really tough.

For me, I don't really know when that's going to happen. Right now I'm just trying to take these strides in what society thinks a man is. You know, going to school and getting a job and being able to stand on my own two feet. It's going to be a difficult road, but it's probably going to be well worth it.

Nathaniel Manning

Young man, there are a couple of different factors that make you a man. You have to be financially stable, that's one. You definitely got to have your own place, your own roof over your head. You have to go to college, and that goes for all the young men out there. I mean that's one step you've got to take to lead to financial stability. You have to be taking care of yourself. And buy your mama a house, then you become a man!

There's this clear thing, and I want you to know, for everybody. The boy who knows how will always have a job, but the boy who knows why will always be the boss. You learn why in school. You learn how by someone telling you. Tell Johnny to go over there and turn that switch. He hit the switch, the light come on. Ask him why did the light come on, then he has no more conversation. You have to teach him why the light came on.

Cecil Willis

FAHEEM MAJEED

QUESTION BRIDGE: BLACK MALES IN AMERICA

Q:

MY QUESTION IS: WHICH ONE DO YOU CONSIDER FIRST? ARE YOU BLACK OR ARE YOU A MALE? ARE YOU AN AFRICAN AMERICAN OR ARE YOU A MAN?

Morris Brent

When I wake up in the morning I see a proud, distinguished, on-his-verge-to-be-successful, black man.

Danny Simmons

It's sort of hard, coming up in America, to divide black from anything that relates to black people—my manhood or anything else. For me to define myself entirely as a man, sure, I could go ahead and do that. I could just say, "I'm a man." Being a black man is completely different, but that's not the reality that I face. I'm judged not as a man, I'm judged as a black man.

Kalup Linzy

When I get up and look in the mirror in the morning, I feel like I see a man, but I feel like there's other energies that I feel that sort of . . . Yeah, I feel like I'm a man. I do feel—I feel like I'm a man first, only because—that's a tough question because I think in terms of sexuality. All this other stuff could come into play in terms of identity. I just mean that in terms of energy and how I relate to other people, I feel like I'm a man, but I never wake up and say, "Oh, I'm going to hang out with the boys today." In terms of being black, I live in a black neighborhood, but . . . I'm a man. I'm a man first, never been a question about that. I think because I have a sexuality issue, I think my more commonality is my identity and my relationship. Even thinking about my mother and father and how I relate to them, and people in my family, it seems to be more of a gender issue.

Gregory A. Stanton

Definitely when I wake up each morning the first thing I see is a black man.

Michael Liburd

I identify first as a man, and then as a black man, and as an American man, and frankly, my family is from the Caribbean, and I look at myself as a Caribbean American. So I guess, in that order, that's how I identify myself. As a man first, and then I identify my heritage from there.

Gavin J. Armour

I am a man. That is what I am. It just so happens that I'm a black man and I live here in America.

Corey Baylor

I'm a man. I'm a man first; there's never been a question about that.

MALIK YOBA

Q:

SO HERE'S ONE, BLACK MAN: WHO STARTED
THIS [NODS HEAD, MOUTHS "WHAT'S UP, MAN?"]?
WHAT IS THAT? WHY DO BLACK
MEN DO THAT? AND I NOTICE WE ONLY
KIND OF DO THAT IN AMERICA. WHEN I'M UP IN
CANADA, WORKING, I DON'T REALLY SEE TOO MANY
CANADIAN BLACK MEN DOING [THAT]. WHAT'S
THAT ABOUT?

Anansi Knowbody

It's about acknowledgement, solidarity. Whether it's a head nod or a bow, or a chin up, it's an acknowledgement of another guy, when you see one another.

Michael Liburd

We're just saying, What's up? It's the universal acknowledgement, at least in the United States, of how you say, What's up? I'm more concerned about the brothers that don't give me the nod. Those are the brothers that I wonder about, the American brothers who look the other way or put their heads down when they see me coming. I look at every black man that I walk by. I look him in his eyes, and I'm waiting to give him the nod. That's how I'm living, and that's how we should all live as far as I'm concerned. When they don't give me the nod, that's when I want to know what's up.

Jermayue Edwards

Brother, we do that because we sure with each other, you feel me? That's my brother over there. I don't have to walk up and touch him to acknowledge him. I can just let him know that I see him, and I'm acknowledging him from a distance. That's why we say, What's up? You feel me? Straight up.

Eugene Varnado II

That's an interesting question, because when I was in college, I went to a mostly white university, and when we had orientation it was stressed to us, when you go walk throughout the campus, you acknowledge all of the black people because there's not that many of us. So you see a brother walking, you say, Hey, what's up? And that has progressed throughout my life. You see a brother, and, Hey, how you doing, brother? What's up, brother? And I think what that does is—I'm not sure who came up with that, but I think what that is, is an acknowledgement that I see you, I understand you, I know what you're going through. You and I have a common bond, and it's unspoken. I don't even have to say anything more than, What's up, brother? I see you. I think that's what that means. Where it came from, I'm not sure. But I'm kind of glad it's here.

MALIK SENEFERU

Q:

BLACK MAN, WHO ARE YOU?
WHO ARE YOU AS IT RELATES
TO YOUR PURPOSE WITH
HUMANITY HERE ON EARTH?
WHO ARE YOU?

Armani McFarland

Hi, and . . . the other questions were easier! You just threw this at me! . . . Speaking for the black people, but as an individual, I think I'm here to make change, to create new things, and to live my life. That's why I think I'm here on earth. And what I want to do is have fun with my life and create change and do things and find out things that people don't know and do things people never seen before. That's why I think I'm here on earth.

Charles Hollins

I'm a black man. I'm somebody that stands for greatness, somebody that wants better for myself, somebody that wants better for my community, and somebody who just wants the world to be a better place, not just for me, but for everybody.

Frank Greene

So the question is, Who am I? I'm just like other people, trying to create a better world with the resources I have.

Tillman-Curtis Liggins

I think I'm here to be an activist and a voice, for not only black men, but also gay black men.

DeMario Patton

I don't really know exactly who I am, but I know who I want to be. I want to graduate from college with a degree, work in juvenile, and help youth. That's what I want to do, but I don't know what life brings.

Marcel Waldron

I'm a black man. I'm a father in the community, a father in my household. I'm a husband, I'm a son, I'm a nephew, I'm an older brother, I'm a good friend, I'm a working man. What I'm here to do is what I've done. Not the bad, but the good, and that's how it should be looked at.

Jamel Shabazz

I am a dedicated father, husband, friend, and soldier to my community. I have a profound determination to continue to hold the torchlight of our ancestors.

MICHAEL HARRIS

Q:

MY QUESTION IS: IF ALL
WHITES WERE GONE, WHO
WOULD YOU BE? WHO WOULD
YOU BE, BECAUSE BLACK IS
NO LONGER RELEVANT AS A
DEFINITION WITHOUT WHITE?

John Kingsley Holton

I'd be who I am. I'd be John Holton. I'd be the person who is speaking to you. I'd be the person who is a member of a family. I'd be the person who intends to strengthen his family every day. The absence of white people doesn't define or limit my definition of who I am.

Yaakov Curry

Great question. I think I would be a chief. Me and my brothers would have our own cattle and land, and I would tend to my land. I would still—more than likely without whites—be in Africa. And I don't know, I would probably have three or four wives looking forward to being the elder of my tribe. I don't know my tribe. I could be Parleelashootiashantee [sic], 'cause I don't know. I believe I would still be in Africa, enjoying life and being civilized, and just improving the world. Improving the world from an African point of view.

Julian O'Connor

The diversity within a community is usually greater than the diversity outside of that community. The same struggles with problematic views are still going to exist, except the people parroting those differing ideas would be people who looked like you as opposed to that abject other who you could now point to and say, Well, they're the problem.

Julian T. Roberts

If all whites were gone, well, you know, if you look at a map of the world, you'll see that this peninsula of Asia called Europe is not a continent. They, as a stand-alone, make little difference in this world. They have, through this modern history, conquered things militarily, but I don't think that they would be missed if they were gone.

Nelson George

The truth is, if there were no people of European—white people, as we call them—there would still be yellow people, there would still be red people, there would still be a wide range of colors. So I don't want to presuppose the world as just black and white, because it's not just black and white. It's much more diverse than that. There's many, many people in the middle between black and white. The other thing is, you know, if you look at the history of precolonial Africa, you're talking about a history of tribalism, regionalism, ethnicity. One thing, if you really go to Africa and deal with Africans, they're ethnically different. The ethnic difference in Africa is no different than the ethnic difference in Europe. The Kenyans and the South Africans and the people from what we now call Nigeria are ethnically different, and they are very aware of that. It's what defined Africa before the white man came. So to say that if we remove white people that the basic rivalries, the basic ethnic differences that kind of define people, would disappear, is a fallacy.

Jamel Shabazz

If whites were taken off, if there were no whites on Planet Earth, I would still be a proud, dignified black man. And I would still have a profound determination to bring about love and unity within my community. So nothing would change for me, because within our community today we still have problems. Self-hatred is still very prevalent. We are still continuing with the skin issue amongst ourselves. So if every white were taken off the face of the earth, our problems would still be the same.

LONNIE
GRAHAM

Q:

WHY IS IT SO DIFFICULT FOR
BLACK AMERICAN MEN IN THIS
CULTURE TO BE THEMSELVES,
THEIR ESSENTIAL SELVES,
AND REMAIN WHO THEY
TRULY ARE?

DeMario Patton

I'm always true to myself, but it's just that when I come outside—I'm living in Bayview-Hunters Point [San Francisco], where it's dominated by African Americans—it seems I always get looked at a different way, stared at, or even called names, and it's kind of hurtful, coming from my own people. We're all supposed to be united, grew up in the same neighborhood, and it's just the put-downs kind of make me not so true to myself.

William Bunn III

As a race of men we have been given a set of standards that are not our own standards. There's so much media hype and feedback that doesn't allow us that sense of knowing who we are. And when you think about the concepts of slavery and what has been passed down through the years and generations, being yourself takes a great deal of work, a great deal of study. It takes a great deal of introspection to be able to go inside and find who the real you is.

Christopher Briellard

For me, it's the fear of persecution. I went through that as a younger person to where if nobody else is doing it, I don't want to be the first person to try out a new style or anything, I don't want to be my authentic self. I don't want people to see the real me. I'll do that around different people, I'll show them my authentic self. But when I come back to the hood, I got to put on that mug because I don't want anybody to try me.

Jamel Shabazz

It is so hard to be yourself in this day and time because in a sense we're dealing with a jungle atmosphere. You have to be strong; you sometimes have to put on this front in order to survive. It's a hell of a thing. I've met a lot of real good brothers in my life, especially in prison, and they put on this hard persona. It's not who they really are, but it's about survival right now. We were taught to be hard. We were taught that if you smiled, you were soft. So we walk around with this temperament that's not really the real person.

Morris Brent

I simply think that it is difficult for some of us to be who we are because we don't know who we are. We don't know what our passion is; we don't know what makes us angry; we don't know what makes us black. We don't know why we should be happy to be black. We don't know why we should be happy to embrace some of the things that other cultures may deem adverse in our history and our culture. You have to embrace that, you have to know who you are, and it should never be difficult to be who you are. Not just as a black person but as a person, period.

Jonathan Poullard

I'm not sure that the question invites a fair answer. It suggests that there's a monolith of how black men are supposed to be in this world. So if I'm being my true self, what does that really mean? So I think the question might be reframed. How does one authentically show off who they are in their black skin?

I think we are all becoming. I don't think there is any essentialized self that you are born to be or are. We're all on a path toward taking on new and more complex and interesting identities. And my hope is that African American men and boys will try to understand that there is no essentialized you, and you can be whomever, however, whatever you choose to be. And you can go back and change that if you want to.

Guthrie Ramsey

LOLIS
ERIC ELIE

Q:

I'M TRYING TO FIGURE OUT THE PARAMETERS OF
BLACKNESS. I KNOW THE STUFF THAT I'M SUPPOSED
TO BELIEVE AND READ AND LISTEN TO AND LOOK AT
IF I'M DEFINITELY GOING TO BE BLACK, LIKE IN THE
HEART OF BLACKNESS. BUT I KEEP WONDERING—
SUPPOSE, FOR EXAMPLE, I PREFER TO LISTEN TO
CLASSICAL MUSIC OR TO TRAVEL TO PLACES WHERE
THERE ARE NO BLACK PEOPLE OR I LIKE PICASSO
MAYBE EVEN MORE THAN I LIKE ROMARE BEARDEN
OR JACOB LAWRENCE. AM I STILL BLACK? HOW DO
WE FIGURE OUT WHERE THESE BOUNDARIES ARE,
IF WE WANT TO BE A PART OF THIS COMMUNITY?

Robert Edwards

See, I've always believed in dealing with different types of people. I was never stuck in one type of box. Basically, the answer for that is, you can do whatever you want to do. Just always remember that everything comes from black, you know what I mean? So you can deal with whomever you want to deal with. I like white people. I've got a few white friends. There's not—nothing wrong with that. It's your choice to do what you want to do. But always remember, try to rub off, try to take what you want to take from certain people, do what you need to do with it, and create whatever you want to create, brother.

E. Patrick Johnson

Blackness is something that we create, something that we experience, something that we live. And part of that is about being in a body that's perceived as black, a body that's beaten on the street, a body that's arrested, a body that is put in jail, a body that is put on death row, a body that is left to die during Hurricane Katrina. All of those things are about being black and living in a black body. At the same time, blackness is about creating a definition of blackness that can encompass all of the spiritual, performative, and celebratory things that we do as black people. So that's why we have something called soul food, but sometimes we have to spice soul food up by giving it a Korean flavor or spicing it up by putting our own twist on it. So we create blackness in various forms. I think there are some instances where black is not a color but a culture, and when we talk about blackness as a culture that means we can all create it.

Christopher Briellard

Brother man, yes, you can still be black. Venus Williams, Serena Williams, Tiger Woods—they went outside of the box and they did something that normally black people don't do. Myself, I like all kinds of music and all kinds of food. Most people who may have looked at you and said you're not black for liking them—maybe they have ignorance to it. Keep doing what you're doing, and try to expose them to it sometimes. But again, brother, yes, you are black.

Roderick Tannehill

Yes, brother, you is still black. It doesn't matter what you do. You can do anything you want to do. It's a free world, free country, but at the same time . . . I wanna do those things; I wanna get up out here and do them with you, brother. Holla back at your boy.

Ronald Porter

Oh my God, I am so fucking sick of regulatory blackness! Because this is what your question is all about. What do I have to do in order to prove my blackness? Let me just answer your question like this. I know that I come from a rich tradition that is as diverse as it is deep. I don't have to do particular things in order to prove that I'm more or less black. It's absolutely ridiculous, and I think it makes us schizophrenic. I think it makes us crazy to run around thinking, well, if I don't listen to hip-hop, I'm not black enough. If I go to rock concerts or something, I'm being white. If I do this or do that, I'm not seen as being a full black person in the black community. Fuck that shit! I'm black. I'm proud of that. And I don't have to adhere to all of these cultural norms in order to prove that.

EDUCATION COMMUNITY & FAMILY

OMARR FLOOD

THIS IS FOR THE BROTHERS THAT GO TO SCHOOL, THAT HAVE BEEN TO COLLEGE, HAVE DEGREES, POSSIBLY HAVE WELL-PAYING JOBS. WHAT MAKES YOU BETTER THAN A BROTHER WHO CAME FROM POVERTY, WHO STANDS ON A STREET CORNER, OR WHO WORKS A GARBAGE-MAN JOB OR A JOB THAT'S NOT MAKING AS MUCH AS YOU? WHAT MAKES YOU BETTER?

John Hope Bryant

Brother, that's the wrong question. Nothing makes me better. If you look in my eyes now, you're probably seeing anger, frustration—it's not anger actually, it's frustration. I'm just sick and tired of being sick and tired. I'm tired of the excuses; I'm tired of the problems. I'm almost saying to my people, stop having babies. If you can't be a parent, if you can't be a father—if you don't know how to be a father, ask somebody! But I'm tired of babies having babies, and I'm tired of black men not showing up in the lives of black men. Because then we wouldn't have to ask these stupid-ass questions because you'd have somebody at home answering these questions! And what made an Andrew Young an Andrew Young is that he had a father and he had a mother. What made me me is that I had a father and I had a mother— the only probable difference between my life and your life. Because I bet you're just as smart, if not smarter, than me. Because if you are surviving in America without all the traditional attributes and the education and the credentials, you are one solid hustler.

So the old John Bryant would blame my friends, you're lazy, get off your rear end, go get a job. This John Bryant says, we come from different places, but we're all God's children and I hear your pain. But what are we going to do about it? What are we going to do about it? Because over or around it, we've got to get to it, because nobody cares. Nobody cares about your drama. At least in Dr. King's day, you had love and hate. You knew exactly where people stood. Today you don't have love or hate, you have indifference. Nobody cares enough about your drama to hate you. So when I go into schools I say, stop the flossing, stop the profiling. Nobody gives a damn about all that. We have made dumb sexy. We have dumbed down and we have celebrated. We have got to make smart sexy again. One to five . . . I live my life eight to ten. One to five is mediocrity. The Bible says, be hot or be cold; if you're lukewarm I'll spit you out. Translation? Even God doesn't like mediocrity. Five to seven is entertainment. That's the woman you date, but you don't marry. Eight to ten is excellence. Brother, live your life eight to ten.

RONALD PORTER

QUESTION BRIDGE: BLACK MALES IN AMERICA

SO I TEACH AT A UNIVERSITY. I COME ACROSS SO MANY YOUNG BLACK PEOPLE, ESPECIALLY BLACK MALES, WHO SEEM LIKE THEY'RE AFRAID OF BEING INTELLIGENT, LIKE THEY'RE AFRAID OF BEING SMART. SO HERE'S MY QUESTION: WHY ARE YOU AFRAID OF BEING SMART? WHY ARE YOU AFRAID OF BEING INTELLIGENT? ARE YOU AFRAID THAT PEOPLE ARE GOING TO SAY THAT YOU'RE ACTING WHITE? ARE YOU AFRAID THAT PEOPLE ARE GOING TO SAY THAT YOU'RE GAY BECAUSE YOU'RE SMART? I DON'T UNDERSTAND IT. WE COME FROM A VERY STRONG TRADITION OF BLACK MALES WHO ARE NOT AFRAID TO SHARE THEIR INTELLECTUAL GIFTS.

DeMario Patton

I think that's because, well, for me, growing up in San Francisco, going to high school out here, it's really mostly becoming diverse. There's black people in the class, but not that many, and the teachers there mostly call on other students because they think that African Americans don't really know the answer, that we're slackers. Well, that gave me low confidence, so I didn't really participate in class a lot of the time.

Armani McFarland

The reason I think why black people don't want to seem smart is because they won't be taken seriously by their friends, or other guys, or their environment. And black people—well, let me say black men—don't take school serious, and they think that school isn't really for them. They could do things outside of school. They're better at other things. That's why black people don't seem smart, but we are smart. That's how I see it as a black, individual man.

Keunthi Davis

Most people are scared of being smart because they're scared of getting teased, scared of getting talked about. They scared of what people might try to do to them because of their smartness. And they don't want nobody probably trying to be they friend just to get them to do their homework for them or something, or to stop getting bullied or whatever. There are a lot of reasons.

Tillman-Curtis Liggins

So I can definitely say that for me, it's not about me being afraid that I seem smart or that I'm going to come off as being gay. Well, one, I am gay, so I'm pretty confident about that. For me, it's about that I'm scared that I won't be able to deliver after gaining this knowledge. That's all I got.

ROBERT EDWARDS

Q:

I LOVE OLDER PEOPLE. I RESPECT OLDER PEOPLE.
I LIVE FOR OLDER PEOPLE, BECAUSE I COME FROM
SOMEBODY THAT'S OLDER. SO FIRST AND FOREMOST
I WANT TO SAY, WE DID DO WRONG. WE DID THINGS,
WE STEPPED ON OURSELVES. I DON'T RESPECT HOW
YOU LOOK DOWN ON US, HOW YOU TREAT US A
CERTAIN TYPE OF WAY. IT'S ALL RIGHT; WE'RE GOING
TO DO IT FOR THE NEXT THIRTY YEARS. WE GONNA
DO WHAT WE GOTTA DO. BUT I SHOULD HAVE SAID
THIS FROM THE BEGINNING, AND I'M GOING TO SUM
IT UP WITH THIS—WHY DIDN'T Y'ALL
LEAVE US THE BLUEPRINT? PEACE.

David Lemieux

I suppose some of us, myself included, feel like we did leave a blueprint. If you had experienced the euphoria that we felt during the '60s, when we would see one another on the corner and it wasn't no such thing that you had to throw up some kind of gang sign. When you saw other black people you went like this [raises fist], they went like that [raises fist], everything was fine. That's not the way it is now. I thought, me as an individual, because I can't speak to other people, I thought there would be a continuum. I thought that if I raise my children a certain way things would stay that way. I thought that we were progressing. I underestimated the seriousness of our enemies. I underestimated that so much time and effort would be spent dismantling those things that brought about self-esteem, those things that brought about self-love, those things that brought about respect for one another. A great deal of time and energy was spent dismantling that by our enemies. And it is our fault that we did not see that for what it was and combat it more thoroughly.

Ambassador Andrew Young

I think that maybe we did leave you a blueprint. And yet, we too were so busy trying to survive that we were not as organized and disciplined as maybe we should have been. But speaking from the platform of Martin Luther King's civil-rights movement, MLK never had more than one hundred people on his staff, and that was only for one or two movements. He never had more than a half a million dollars a year to try to change the world. None of us had a blueprint, but what he taught us to do, and what we learned from Gandhi in India, was that we could find our own way by standing up for the truth.

Darryl Norton

I think that we left you the blueprint; we just didn't tell you where it was. It's there, but we didn't just show it to you or lay it out. You had to look at us and see what we were doing to find out how to go about that blueprint. You see, some things can't be explained to you, some things you've got to look at a person and then you've got to see what it is that they're doing. The blueprint is, you get an education. You don't just be in the middle of the road. You don't try to be with the kids that don't do well, you try to be the best, okay? You do as good as you can, no matter how angry people become when you're really good. You know what, success is not easy. It is not. If it were, everybody would be successful. It takes time; it takes hard work. Everybody is not geared for hard work. Some people want it overnight, and it's not going to happen that way. So what you have to do is—we old people, we've laid the groundwork for you. We've already put the blueprint out there. You might not like that blueprint. You might want to alter it in some way, and you can. But if you alter it and it's not for the better, you will not achieve what us old folks have achieved.

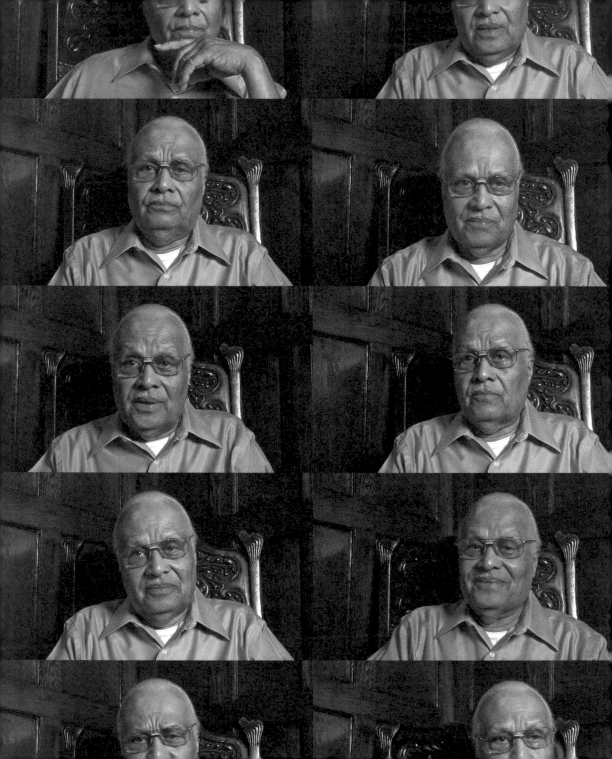

After the civil rights movement of the '60s proved to be very, very successful, I think blacks felt like we had crossed a threshold and that it was easy going from here on in. But the worst was yet to come. I kind of think that we thought that the waves would continue to roll, and we did drop the ball, only to find out later that other people were making plans and were putting certain kinds of Negroes in head of organizations and paying them well. And they became the spokespersons for black people, and they became the protectors of the plantation, being paid by white people.

Reverend C. Herbert Oliver

ANTHONY TROCHEZ

Q:

GROWING UP, I'VE SEEN BLACK PEOPLE
WHO'VE MADE IT OUT—EITHER FINANCIALLY
OR EDUCATIONALLY CHANGE WHO THEY
ARE. SO MY QUESTION IS, HOW HAS YOUR
FINANCIAL OR EDUCATIONAL SUCCESS
COMPROMISED WHO YOU FEEL THAT YOU
ARE ON THE INSIDE FOR WHAT YOU FEEL
THAT PEOPLE WANT YOU TO BE?

Tony Brown, MD

I'd have to say the first answer is that I feel like I've compromised my membership in the black community. It's not because I left the community, or the community left me. But it's as if there's a zero-sum game, that the more successful a black man becomes, the less the community seems to embrace him. And it's also got a little bit to do with how that black man is defined by the nonblack world. It's as if your success makes you "other." An example of a conscious way that I did that is with the soul shake. I remember growing up in Dallas and meeting my friends on the street, and you walk up to them and you give them a soul shake. I also remember the day that I stopped doing that, on the courtyard at Harvard. I remember walking up to them and instead of giving them a soul shake giving them the corporate handshake. I remember walking through the hospital, the floors, and doing the same thing, being conscious that when I see my friends I should just give them the corporate handshake. And you know, the disappointing thing was, one day, walking down the hall was a cardiothoracic surgeon who came up and soul-shook me. The moral to the story is, don't try to be black, just be yourself. By definition, you're black.

Alex Morgan

It has not changed me at all. What has changed is people's perceptions of who I am and what I'm about, and which, in the black community, have created a dilemma. Because we have the idea that an individual who has succeeded is now not part of that community but part of some "other" community that we believe we're not a part of.

Ronald Porter

On the one hand the reality is, when we get into these positions of power, we make people uncomfortable. So that's one thing, on the one hand. On the other hand, in all different types of professions, there are certain things that you have to do in order to be successful. There's certain ways that you have to be. But there's a difference between adapting to different situations and being in a hostile environment because you are black. So I haven't changed who I am. I've gained new skills. I can adapt to many different situations, but I am still me. I am still me at the end of the day, and I'm not afraid to be that.

Julian O'Connor

Imagine yourself being a knight, and you're riding into battle. A knight has to put on his armor, and a knight has to have his shield and sword. For me, if you're going into a corporate environment, you can't go into a corporate environment the same way you would if you were going to your grandmother's house, or if you're going to McDonald's, or if you're just comfortable. There is a code, and there is a shielding, a layer of protection that you need for all of the harmful things that are going to be in all of those environments, because they're equally treacherous. I just look at it as, you've got to be confident in who you are, know who you are, and just know that in certain environments you have to dress a certain way, and the way that you speak is just about how relaxed you feel in those environments.

Nelson George

There's a thing in this world called maturity. It's something that is sort of undervalued in the black community today because people tend to be centered around this idea of what I call "ghetto-centricity." That is, that the ghetto is at the center of all black expression, which is a very recent phenomenon and a very divisive one, because the truth is, everyone evolves. No one stays the way they were when they were eighteen, nineteen, twenty. If they did, they wouldn't be human. I wouldn't know what they'd be. As black people, as black men, we need to be in the process of evolution. There's no ultimate blackness. There's no ultimate black street credibility. There's who you are then, what works for you at that moment, and who you become next, and who you become next, and who you become next. You take everything that's ever happened to you and you keep adding on top of it. And that's life.

EDWARD D. ROBINSON, JR.

Q:

MY QUESTION TO YOUNG BLACK AMERICA, THE YOUNG MEN OF BLACK AMERICA, WOULD BE, WHY DO YOU HAVE THAT "TAKE" MENTALITY? THAT "I WANT WHAT I WANT RIGHT NOW. I DON'T WANT TO GO TO SCHOOL. I DON'T WANT TO WORK. I DON'T WANT TO LEARN. I JUST WANT TO TAKE WHAT I WANT, REGARDLESS OF WHO IT'S GOING TO HURT, WHO IT'S GOING TO BOTHER, WHOSE MOM IT'S GOING TO SEND TO A FUNERAL HOME, WHOSE DAD IT'S GOING TO SEND TO PRISON." WHY DO YOU HAVE THAT "TAKE" MENTALITY? THAT'S MY QUESTION.

Gabriel Daste

The "take" mentality. A large portion of us, if you're talking about young America between the ages of sixteen and twenty-four, all fall in that—well, sixteen, maybe sixteen, eighteen, to twenty-four—fall in the crack generation. So you have a generation of young men who are have-nots. You live as a have-not for long enough, you notice that no one's giving, or no one's giving a shit about you, so you start to take. The generation right before us dropped the ball. From my grandparents to my parents, there was a separation. They didn't understand what my parents were going through, so the disconnect came 'cause they couldn't talk the same lingo that my parents spoke. Same with my parents and the generation right after them, then on to us. That disconnect makes it so that we are not teaching each other, and we're teaching ourselves. And we can only teach what we've been taught, and that's that no one will give you anything, so you take.

Tyrone Dangerfield

As we progress with our technology and the way that technology has came today, we are an instant-gratification world. Everyone has instant access. It used to be a time when kids would go out and play. Whether it's the fact that it's too dangerous in the neighborhoods, or whether it's the fact that parents are too tired because they work so much—kids spend so much time in front of the tube, in front of the TV, watching BET, MTV, or whatever else, the *Grand Theft Auto*, the video games. Those have given kids the opportunity to say, I want this now, because it's in front of their face every day. It's in front of their face every day, and it's up to the families to say, Get away from the tube, and show you some hard work. I remember when I was coming up, how my grandfather would take me out to do hard labor for a bag of McDonald's. And it's not really the same thing anymore. It starts with the families. The families can teach the kids that it's not about the instant gratification, you know, that quick money is not great.

Charles Hollins

I think we have a "take"—I think I have a "take" mentality because everything that I ever worked for and what my ancestors worked for was taken from them. So it's what I'm taught—to take. I'm taught to have that "take" mentality. If nobody's going to give it to me, I'm going to take it. Or if I work for it, somebody else is going to take it. So it's a learned behavior. It can be unlearned.

Corey D. Lawrence

Okay, to answer your question, it's not all black males that have that sense of what you're talking about, that mentality or frame of mind. But on the other hand, on a firsthand basis, I have seen such things happen. You've got a young male, growing up in the projects, that doesn't have a father in his home, and all he's got around him is total chaos. The last thing he has is where he came from, his mama's womb, and the sense of direction that she's giving him is totally, totally, totally wrong. She tells him he better go to school, but she don't have no high school diploma. She don't have anything to tell him about school, or the importance of staying in school and setting goals, and just because you don't got no father figure to be all that you can be. He doesn't have that. He's already got one strike against him: he's in a black neighborhood. No matter how old he is, the authorities riding around still going to harass him. He's in school, he's going to school with rags on, he's being jived on. There's no sense of rest. His mom has every Tom, Dick, and Harry in the house. These brothers might be coming in the house, giving a totally bad, bad sense of direction to him. So when he goes out and he's trying, all he's getting is failure and no one to uplift him, no one to hold him. His mom, or no one else around who's judging him, can't even just tell him all you've got to do

is pray about the situation, he ain't even getting that much.

So what do you expect for him to do, huh, growing up like this? Where do you expect for him to go from that point? It's not like he's older and he's trying to be taught. He's young, and his mom is telling him to stay away from drugs. But she's up late nights, thinking when he's asleep he can't hear her having a good time with her friends, getting high and drinking. Telling him not to steal, but here it is, she's going out in the neighborhood and boosting clothes, but she thinks he don't know about it just 'cause she ain't at the house. Telling him not to do it, but you turn around and do it. You are the one that had him. All this around him, all this chaos, there ain't no one to tell him what's right from wrong. He knows it, but in a sense, he's gonna go get it because survival is something. That's what the young live with. Survive by any means necessary. But it's easy to talk about, but nobody's putting forth effort to make something happen about it, to change it. Clutch your kid. Think about what they're going through instead of judging them. Yeah.

REGINALD WATSON

Q:

I WANT TO ASK YOU A QUESTION, ESPECIALLY TO MY BLACK MEN OUT THERE. DO FEEL THAT YOU WERE DEPRIVED OF YOUR FATHER IF YOUR FATHER WASN'T IN YOUR LIFE? DO YOU BLAME YOUR MOTHER BECAUSE SHE JUST WANTED A BABY AND SHE DIDN'T WANT A FATHER FIGURE, OR DIDN'T HAVE THE ABILITY TO KEEP A FATHER? BUT LASTLY I WANT TO ASK YOU, DID IT MAKE YOU A DIFFERENT MAN? DO YOU THINK YOUR LIFE IS DIFFERENT BECAUSE YOUR FATHER WAS NOT IN YOUR LIFE?

Armani McFarland

How I feel about my dad is, I care for him, but I just don't feel it for him. Like, not at all. 'Cause the things he do, and the way he act, and the way he do things . . . but I do love both of them. I don't blame my mom, I don't blame my dad. People are who they are. But me and my dad, we just don't connect, like. And that's how it is, and it has made me a different person. I am different, and I want to be better to my kids in the future and those types of things. It has made me a different person. I seen how to be a man quicker, how to do things without a dad. A lot of people don't have dads, so if you do, take that into consideration if you have a good dad.

Ivan Montgomery

No, I don't blame my mom, or I don't blame my dad. I think things happen just how they was meant to happen. My dad wasn't a part of my life, but I chose to get better from it, not bitter from it. Right? He taught me how to be a father because he wasn't around. You know what I mean? So now I'm able to give my daughters what I didn't have—a father. You know what I mean? Now that I think about that question, I could give my kids what I didn't have. And maybe what I didn't have is not what my kids need! You know what I mean? I could give them my love, my understanding, my experience, right? 'Cause maybe that's what they need. You know? So I know I want the best for my kids, right? So if I know they want the best, then they don't have to settle for less than the best, right? So, nah, I don't blame anybody. I don't blame my mother or my dad. My mom did the best she could.

Jermayue Edwards

Well I think that it's not really on your mother. My dad wasn't around for a long time, but it wasn't because he didn't want to be. It was because he was in jail. It might have been a few times that my mom did push him away and didn't allow him to come through. But at the end of the day, you just can't go around blaming other people. Sometimes people make mistakes. Just as long as you touch bases with them and let them know that you still love them, I don't see why it should be a problem.

David Lemieux

That's a very good question. I will be the first to admit, I'm fifty-eight years old now, [begins to cry] I'm fifty-eight years old now, and I still have father issues. My father was not in my life. I can't say I blame my mother for that. You know, my mother's white, my father's black. I have vague recollections of him—my father's from Haiti. I don't know if he's dead or alive. There were other men around me, and sometimes as I was growing up, my mother had other friends, people she had relationships with. It's ironic that you mention the father thing, because as a grown man, at the age of thirty, I sort of latched on to this elder, who actually became a father to me. And that's a good thing. And I consider myself very blessed about that. And also, I benefited from the fathers that my friends had, you know, strong brothers that I looked up to. And I would say I benefited from that. I'm an only child. I didn't have any siblings that I knew about, but I certainly don't blame my mother. She did what she could. But do I think that I would have been a different person if perhaps my father would have been in my life, from day one all the way until . . . ? Undoubtedly, in some ways. But I think because of the father figures that I sort of chose, I made some good choices. So I'm good.

COREY BAYLOR

Q:

ARE YOU COMFORTABLE WITH
THE IMPACT OF YOUR ACTIONS
ON YOUR COMMUNITY AND
THE WORLD?

Brian J. Winzer

For years I was comfortable with my impact on my community and the world . . . until just recently, when I started developing a conscience and started getting information that what I'm doing is wrong. When I started developing a sense of wrong. When I started seeing my daughter and my grandkids complaining about what I'm doing, I started realizing that I'm not making a positive impact. And I asked myself one day, when I leave, what type of impact I want to have on the world. And I want it to be a positive impact. If it ain't for nothing else than my family says that I was a good guy and I provided for them in the right way.

Andalib Khelghati

I am. Every day I think about what that is, for me. As I've gone through life, I start every day really thinking about my impact and my actions, and it's never anything that ends. It's something that's really, literally, one day at a time. It sounds cliché, but it's one day at a time, and some days are better than others. Some days I don't feel so good about it, and I'm embarrassed, and I've just got to pick up and try it again the next day.

Tillman-Curtis Liggins

Yes, I'm very comfortable with my actions and with the impact that I'm making on this world. I'm actually part of a group on my campus at Columbia College that deals with social justice, and we're advocates of change. We try to speak up for minorities and the gays and blacks and Asians and the whites. We do it all. And I really feel that my actions through this group will make a difference.

Jabari Mahiri

I'm very comfortable with the impact of my actions on my community and my world. After being drafted to a war that was not of my own choosing, what I wanted to do with the rest of my life was to make a contribution and to give back. So rather than going into a profession—even though I had a college degree— I worked for fifteen years in community organizations, trying to turn our community issues around in favor of black people. But at the same time, I don't want to pat myself on the back. I just think that's something that we should all do, as a commitment to ourselves and our families and our communities.

David Lemieux

Yes, I'm very comfortable with the impact of my actions. When I was sixteen years old, I was in the Black Panther Party, which was one of the greatest experiences of my life. I was part of an organization that took a lot of risks. We did a lot of things that served the community. As a matter of fact, our effect was so profound that J. Edgar Hoover called us the most dangerous threat to the stability of the United States that's ever existed. Seeing as the United States was founded on the genocide of the Indian and the enslavement of the African, I consider that an honor to have someone say that we were dangerous to the stability of these United States. That being said, in 1982 I came on the Chicago Police Department. I'm now retired, and I use my position to continue to serve the community, not as a representative of the police department in the community, but as a representative of the community, as to the way policing should be done in our community.

MALIK YOBA

Q:

SO, QUESTION. WHY IS IT SO DIFFICULT FOR BLACK MEN TO GO TO THE DOCTOR ON A REGULAR BASIS TO CHECK OUR PHYSICAL HEALTH OR OUR MENTAL HEALTH?

Eternal Polk

It's a very deep question, no pun intended. Historically there are instances where black men have gone to the doctor's and came out with diseases, such as syphilis, in the Tuskegee experiment. Black women have gone into the clinic and came out sterilized throughout history, whether it's in this country or abroad.

I think that with the historical and very real aspect of black people going into the doctor and coming out with either an ailment or some sort of procedure done on them without their being aware of it, I think that's a very real reason why black people—and men in particular—avoid the doctor, avoid getting that sort of information.

Nathaniel Manning

Going to the doctor is definitely not difficult if you've got the money. So growing up in a household where, you know, medical benefits wasn't even something that we could even compromise—mean we had remedies from Grandma, because we didn't have the money. Those are the things that we reverted to. So I think it's, you know, health costs. And it's not having that financial stability to go and get yourself checked, even if you're feeling something's wrong. We told Granny, and Granny gave us those down-south remedies. And I'm not saying that's right or wrong, but that's what we had to deal with because of the financial situation we were in.

Tillman-Curtis Liggins

I don't feel that there's anything wrong with it. Some people need that person to talk to. But you know, as far as I go, I don't need nobody all in my business. You know, I'm already judged on everything that I do, and I feel that going to that therapist will bring up some issues that I don't want to deal with, and I don't want to be judged about. So for me, I just don't go.

Gregory A. Stanton

You picked the wrong person to ask that to! As a therapist, I can say that ninety percent of the people that have come to me have been African American females. And the other ten percent would be the males who have come. And usually they come with reservation and hesitation because they believe that when you begin to look inside is really saying that there's a weakness, not realizing that we all have imperfections that can be perfected, not realizing that the therapeutic environment—many of us have no clue what goes on in the therapeutic environment—that we don't take the opportunity to have that experience. So I say that most of us don't do it because of the unfamiliarity with what it really is all about.

Well, you've got two aspects. You've got your physical health and your mental health. And typically, black men go check out their physical health is when they're at such a bad point. They feel so bad, and their health is so lousy, that's when they go. My brother, I told him three years before he had prostate cancer, "When's the last time you had your prostate checked?" He said, "Aw, I don't get that done." I said, "When's the last time you been to the doctor?" "Oh, about four years ago." I said, "Man, you need to go!" I told him I get mine checked all the time, and I said "colonoscopy," and I told him all these things. Three years later, he had an advanced stage of prostate cancer, it had metastasized, and he died.

But I sometimes get angry at him because when I told him what to do, he refused to do it. [Begins to cry.] And to this day, to think about it, it hurts because he could have done something. He could still be here. He could still be with me. What did he do? He wouldn't listen. I should have made him go. [Cries.]

And you see, that's one thing about black men. We think we're so strong. We think we're so great, and we don't need anybody, and we're okay, and there's nothing wrong. That's not true. Your mental health, too. I mean, some black men don't even know that they have depression that could lead into suicide. And what do they do? They don't do anything about it. And so, I can't understand why they don't do it.

Darryl Norton

RELATIONSHIPS & SEXUALITY

DARRAN SIMON

QUESTION BRIDGE: BLACK MALES IN AMERICA

Q:

WELL, ESSENTIALLY WHAT I WANTED TO KNOW FROM BLACK MEN WHO'VE BEEN MARRIED FOR SOME TIME—TWENTY-FIVE, THIRTY-FIVE YEARS OR SO—I WAS CURIOUS AS TO, HOW DID YOU KNOW THAT SHE WAS THE ONE FOR YOU? HOW DID YOU KNOW THAT SHE WAS A WOMAN THAT YOU WANTED TO MARRY AND SPEND THE REST OF YOUR LIFE WITH? THE REASON I'M ASKING IS, I'VE BEEN DATING A YOUNG WOMAN FOR ABOUT A YEAR OR SO AND I FEEL THAT SHE COULD BE THE ONE FOR ME, BUT I JUST DON'T KNOW WHAT THAT FEELS LIKE.

Delroy Lindo

This is an instance in which you really have to trust yourself. For myself, I will say this: when I met my wife, it was at the end of a period in which I'd been dating a lot. In all of the relationships that I had had, at some point I could see the end of the relationship. I could see it coming.

When I met my wife, I could not see the end. When I met the woman who became my wife, I did not know necessarily that we were going to be married. But I knew that we were going to have a relationship of major significance, and I also felt—and I can't necessarily describe the feeling—but I just felt inside of myself that I could not see the end of our relationship. So what that said to me was that we could—it was not necessarily— it was not a finite dynamic that was going on between us. It felt infinite. It was something I could not see the end for. And that was how I knew that this woman, the woman who became my wife, was going to be majorly a part of my life.

Gregory A. Stanton

Well, you have the essential ingredient already. You mentioned "you feel like." Your feelings are a great vibration of if it's good or bad. As far as whether or not it could be a long-lasting relationship, that's based on the collaboration between the two of you all, working with common goals and going in the same direction.

Having experienced marriage for thirty years—the power of passion and the pain of being in a relationship and realizing that she is a reflection of me, and where there were problems and challenges was a reflection of things I needed to deal with. When you come to a long-term relationship, love is a choice. Relationships also are choices, and if you choose to build and maintain a relationship, you can.

Julian T. Roberts

Well, I guess that I've been with my wife now for twenty years, which doesn't qualify for that twenty-five or thirty that you're talking about. But when we met, we really liked being with each other, and on our first date we just stayed together for every day after that, almost.

I don't really think that there's an answer to the question, Is this the woman that I'm going to spend the rest of my life with? And I say that because there are many times in your life where you'll meet a woman that you are infatuated with, and you'll fall in love, and you'll fall in lust, and you'll think that you want to be with this woman. But you don't really know anybody until you encounter the journey of a relationship. It's a fantasy that you'll find somebody that you'll know is the one who you want to be with the rest of your life, and you don't even know her.

Darryl Norton

In answer to your question, I dated my wife for probably almost three years before we got married. But I knew from the time that I first met her that she was someone who I wanted to spend a lot of time with. She was soft, she was gentle, she was understanding. I used to write my last name with her first name over and over again on a yellow legal pad. I must have done that one hundred times. I used to find ways to just see her because I just liked being around her. She made me feel good. This was before we ever started going out or anything. It's a feeling that you have, and it's not something that you question. But if you have it, you'll know it.

Ambassador Andrew Young

Well, I've been married twice, and I was married first for forty years before my wife died of cancer. But I decided that she was the one before I even laid eyes on her. And I decided that because I went to her house and I saw a Bible, and it was underlined. I said to her mother, "Whose Bible is this?" She said, "That's my baby daughter's Bible." And then I turned and looked on the wall and there was a senior life-saving certificate. I said, "Who is this?" She said, "That's my daughter." I said, "The same daughter that has the Bible?" And then there was a basketball letter on the wall. Well, I'd been on the swimming team in college, I was in seminary, and I had never met a woman—black or white—that was athletic and religious. And I didn't know what she looked like then, but I knew from her mama and her daddy that she couldn't be too far gone! And then when I met her, one of the first times we were together, I made the mistake of saying, "Come on! I'll whip you at a game of horse on the basketball court!" And she said, "Ain't no mere man gonna beat me." And she proceeded to shoot me off the court. And I said, "The Lord sent me to this little country town for something, and you must be it."

Well, she wasn't interested in preachers and didn't want to be bothered with me for a long time, but I had made up my mind. She was from Marion, Alabama, which happened to be the same town that Coretta King was from, and the same county that Juanita Abernathy was from. Well, I didn't know Martin or Ralph then, but Jean and Coretta knew each other, had gone to the same high school. And to me, it was divine providence that sent me there to meet this woman, so I was committed. And she used to say, jokingly, I hope, "You told me till death do us part. If ever you try to leave, you gonna die."

We were in the country, so we used to go out in the backyard and shoot at tin cans on a tree stump, and

she could outshoot me. So I learned to be good quick. Her mother and her father had a gun collection, and it was a kind of gun-toting family, but they believed in nonviolence.

When we married and went to Georgia and we were attacked by the Ku Klux Klan—we expected to be visited by the Klan—I said, "Look, I don't mind facing these folk, but you're going to have to sit up in the window with a gun and draw a bead on the one I'm talking to, and then we can negotiate from a position of strength." And she said, "What are you talking about?" And I said, "I mean, we're not going to just sit here and do nothing." And she said, "I'll never point a gun at a human being. And if you don't believe this Christian stuff you're talking, you need to quit right now." And I was talking basically about the safety and security of my newborn daughter who was three months old in the crib. But what she did was, she forced me to think of other alternatives. So, instead of waiting for the Klan to come to me—we were just trying to run a voter registration drive; this was 1956—I went to the business community, the white business community, and talked to them about it. The biggest employers were Flower's Bakery and Sunny Lane Packing Company. And after talking to the mayor and these business leaders, they decided that they were going to speak out against the Klan. They would let the Klan have the rally, but they would not let the Klan parade through the black community and intimidate those that were trying to be registered voters. And so, she not only protected me from the Klan, she protected me from myself, and taught me one of my first living lessons in the power of nonviolence. We not only had a good voter registration drive, but we maintained good relationships between black and white, and this was in south Georgia in 1955 and '56.

It was rough down there then. But because non-violence worked for me there, a little later on, I hooked up with Martin Luther King. And I think that we could not have made it and made the changes if we hadn't married strong women. There were many a time that I'd have said, Fuck it, and got on out of there, but our wives would not let us waver. They said, No, even if it means you get killed, I get killed, our children get killed, we have got to confront this evil called racism and segregation in America.

And when you find a woman like that, you will be glad to spend the rest of your life with her. She give you hell every now and again, too, though, but then she died after forty years, of cancer. She never smoked; she never drank; she ate right; she continued exercising and could always beat me playing tennis. She would make me play the doubles court and take one serve when I was feeling pretty strong, because she was always going to be the winner.

But then two years after her death I met another young woman who was equally as courageous, equally as visionary, equally as loving, and equally as beautiful. Also an elementary school teacher. And I said that God did not mean for me to be alone. My son said, "Daddy, you been married all your life. You could be a player. You somebody. Women all over the world would flock for you." And I said, "Son, I wasn't so much of a player at twenty-one before I married, it doesn't make sense for me to start being a player at sixty-five. I know what it is to be married to one woman and be happy." He said, "I don't know how you can be happy with one woman for forty years." I said, "Well, your mama was more than one woman. She was really many, many women, and we grew up together, and she had said to me, 'You know, when I married you, you were a country

preacher making $190 a month. And I never thought that I would end up being married to a congressman, or to a United Nations ambassador, or to a mayor of a city, or that I would be thrown out into the world to have to head major projects.'" But what you realize is that, in a marriage, you constantly are interacting with each other and you are becoming new people. And the challenge is to learn to find new ways to express that new love, which blossoms in marriage each and every day.

But, it's not a matter of love. It's not a matter of how you feel today. You must be committed to each other on bad days and you must find somebody who will love you when you are unlovable. And you have to love a woman when she's having problems and when she's giving you hell. Usually, she's right. But you won't see it at the time. But, whether you see it or not, whether you're angry or sad, you will find that you are blessed to have committed your life to one person, till death do us part.

ISAIAH McCORMICK

Q:

WHY AM I CONSIDERED A
TRAITOR TO MY RACE, OR YOU GUYS
CONSIDER ME AN OUTCAST, SIMPLY BECAUSE
I CHOOSE TO DATE OUTSIDE OF MY RACE? IT'S NOT
THAT I DON'T LIKE DATING WITHIN MY RACE, BUT
IT'S JUST THAT I WAS RAISED TO BELIEVE THAT YOU
JUDGE PEOPLE DETERMINED ON THEIR HEART AND
THEIR PERSONALITY AND MORAL FIBER, WHO THEY
ARE AS A PERSON, NOT ON THE COLOR OF THEIR
SKIN. WHY IS THAT?

Kenneth Marshall

Well, I wouldn't go so far as to call you a traitor. I don't care, but I'd accuse you of ignorance again. Obviously, your parents, they told you not to have any discrimination, but I'm quite sure that their parents and their parents before them were discriminated against because of the color of their skin. So that's why I'm accusing you of being ignorant, because you obviously are not paying attention to historical events that have transpired and are still going on today. If you go out in public with a person outside of your race, you're going to be ostracized.

David Lemieux

I don't see why we've got to go anywhere. There's brothers that have got blue eyes and ginger-colored hair, there's sisters that are coal black, there's sisters that are buttermilk yellow. I mean, we're a various race of people. There are plenty of people who have made different choices as far as who their personal mate is, and still did things that were helpful to us as a group, as a community. That being said, personally, I believe that our women deserve the best that we have to offer, and whatever I have to offer, that's who's going to get it.

Reverend C. Herbert Oliver

So that's your choice, and if you can live with it, live with it. You're in America, and it's been going on since the founding of this country.

Jabari Mahiri

I'm really conflicted by that question myself because I date outside the black race really frequently. I'm conflicted because on the one hand, I agree that we should be able to look at people for their human content and make those kinds of human connections, and I've done that. But also, politically, I understand that there's ways in which people outside the black race are offered as more attractive, as more of a great kind of relationship, as someone to be seen with. Your status as an African American man, just by who you're associating with and all of that, has denigrating effects for the way that black women are projected and portrayed. So I think that we have a lot of work to do in that area. We don't want to go down the road of saying you can only date one kind of person, but we also have to reflect, ourselves, on why it is that it's so easy for so many of us to look to other women and other racial groups for the most intimate kinds of relationships that we can have in our lives.

Keunthi Davis

Well, my brother, I'm the same way. I wouldn't date *no* black women as well, because black women, they're something else. They're a trip. Black women make you go to the light, you know what I'm sayin'. I also date outside of my race as well, because black women, they will make you do some things that you never thought that you'd see yourself doing.

Darran Simon

I would say that some folks would consider you a traitor to your race because they have a very narrow vision or a narrow view of what love should look like. A lot of times that comes from what they see or what they desire to see. I think because black people don't have and are still fighting for many things in life, they feel that if they see black men with Asian women or with white women, they have to fight for their men. They feel like they're losing their men to prison and various other social ills. I think within that camp, there's also a population of people who will say you're a traitor because they feel that's what they're supposed to say, because it's the black thing to say, and if you see an interracial couple you shouldn't agree with that. But I say, love who you love, and that's how things are supposed to be. I've dated white women. I've dated black women. And as I've gotten older, I know that I should be with a black woman. And I love many things about the woman that I'm with. I love her confidence, I love her poise, I love her strength, I love her attitude. I love the fact that when I fall down she'll pick me up, and when I achieve she'll cheer for me. I feel you can get that more so with a black woman. I'm not saying that a woman who loves you won't cheer for you and won't feel for you when you hurt. But I think a black woman, she knows where you're coming from, she knows where you want to go.

Malik Yoba

Most of my elementary school teachers were white. There was Ms. Coolidge, first grade, blonde hair, blue eyes, cute. Thinking back, she was probably only in her twenties. I had a crush on her. She used to kiss us at the end of class. Back in the '70s, I guess it wasn't called child abuse at that time or inappropriate, so she would kiss all the kids on the cheek when we left class. So one day I got a bright idea that when she came to kiss me on the cheek I would turn my face and kiss her on the lips. So as a little boy I was kissing white women [laughs].

ABEL HABTEGEORGIS

QUESTION BRIDGE: BLACK MALES IN AMERICA

Q:

WHAT DO YOU REALLY THINK ABOUT WHITE WOMEN?

Charles Hollins

I think white women is cool. I don't see nothing wrong with them. I don't see nothing wrong with no race, me personally. That's basically how I can answer that. I mean, they're cool to me.

Danny Simmons

Physically, I've seen some very pretty white women. I've never really dated a white woman. I don't know if that's a character flaw or something. I find some of them extremely attractive, I just feel more comfortable with women of my own race. That might even be racism on my part. I saw a few white women walking here and was like, Damn! and kept walking.

Andalib Khelghati

You know, there's just something special, I don't know. I grew up in Togo, and so I was always something different. As a little kid there was something, I guess you could almost say, exotic, about white women. Because I wasn't them, there was something different, and just something . . . a unique flavor. That's all that I can say, too.

Julian T. Roberts

I don't really think about white women. The fact of the matter is, in my youth I went through all the experiences that we go through to conquer those undeniable things. Then I realized that they're not important. I recognize also that part of our problem of having a question like, "What do we think about white women?" is because we have had this beauty standard imposed on us of which white women are the symbol, and we really need to help our sisters recognize that they are the beauties of the world as they are naturally. So white women don't play a role in that.

Malik Yoba

I think it's kind of sad, though, in 2011, that people still have a problem around other people's business when it comes to affection and love and connection. I think that everyone should love everybody else, as corny and cliché as that sounds. I always ask people who have a problem around folks dating folks that don't look like them, I say, "How does God factor into this?"

So I think that if it wasn't for a white woman, we wouldn't have our current president. I guess a black man had something to do with that, too. So here's a lesson to you: if more black and white folks got together, we'd have more brown presidents. I'm going to go find me some white women, excuse me right now [laughs]!

RONALD PORTER

Q:

SO THIS QUESTION IS FOR ALL THE BLACK GAY MEN THAT ARE OUT THERE, AND I'M NOT TALKING ABOUT THE ONES ON THE DL, OR THE ONES THAT DON'T IDENTIFY, BUT THE ONES THAT ARE OPEN AND HONEST ABOUT THEIR SEXUALITY. HOW DO YOU REALLY FEEL ABOUT YOURSELF? ARE YOU FRIGHTENED ABOUT LIVING OPENLY IN THIS COUNTRY? WHAT DO YOU DO IN ORDER TO SURVIVE AS A FULL HUMAN BEING?

Tillman-Curtis Liggins

I love myself, you know, me being a gay black man. One of my tactics is cutting people off. Some people, a lot of people who have discriminated against me, were people that I know and I love, like my own dad. And it's horrible that I have to cut him off, but in order to survive and in order to not feel that pressure and not feel that angst, that oppression, I have to cut certain people off.

DeMario Patton

I'm not frightened, living in this country. I feel confidence in myself. I'm who I wanna be. I don't listen to other people's remarks, or how they judge me, or anything. I'm me and I'm living life.

Waldo E. Johnson, Jr.

I find it difficult even as someone who others, in some instances, may view as having been successful educationally and professionally, oftentimes to pursue all that I really desired to do without some feeling of concern about potential retribution, or some concern about my aims or my goals being misinterpreted by others. And so it's a constant struggle to be able to do this. It's something that requires thinking about on a daily basis, sometimes thinking and reconsidering one's approach. But perhaps more importantly, it indeed, as you suggest, requires that one be very honest about who he is, and that is something that I seek to do on a daily basis. I really seek to be honest and open about who I am.

Bill Doggett

I'd like to encourage all black gay men who are out to be out and be positive in a community, constructive, building way.

Kalup Linzy

The first question that came to my mind was, do you think both black straight men and black gay men should all come together, hold hands, and sing "Kumbaya?" [Laughs.] I just thought that was silly.

My coming out was kind of supported. But I do wonder if straight men who are homophobic would join hands with a gay man. You know, like a straight man, not somebody who's eccentric, would they—I'm thinking more of the Million Man March, the black Million Man March or something—would it kind of happen, right?

In terms of being open about my sexuality and in terms of surviving, I guess what I do to survive is, I just eat, drink, like everybody else, in a physical way. I think that being myself and being as open as possible has probably helped me and helped my career. But I'd say personal, romantic relationships is the most difficult thing, and . . . I don't know . . . I haven't figured out how to maintain one that's been completely healthy. So that, I don't know. But in terms of career and the other stuff, I just think just being open and keeping things moving has helped me be successful.

Thomas Allen Harris

I came out, or came out to a lot of people, when I was, I guess, in my teen years or twenties. And there's all different ways of coming out. You come out as same-gender-loving, you come out as loving across racial lines, you can come out as loving within racial lines, and loving across party lines. You know, it's interesting coming out. Like, I'm involved with another man of color, an African American man. Right now, we've been together for fourteen years, and he's a Republican. And I find, I mean, talk about cross-cultural combinations! And those ideals, like, being involved with someone who has those ideals but supports people who I think, Oh, my God, that person should be the enemy!, is a challenge, and I don't really talk that much about it. That's a right-this-minute coming out. Does it feel liberating? [Shrugs.] I think that the liberating experience starts with self-acceptance and self-love.

I live openly as a black, gay man, but it took some time for me to get to that place, because for many years I was invested in what other people thought about me. But when I decided to love myself more than what other people thought about me, then all the pieces fell into place, and now I feel free. So my mantra about life is, I just want everybody to be free.

E. Patrick Johnson

RONALD PORTER

ARE YOU THREATENED BY
BLACK GAY MEN? DO THEY
SCARE YOU? DO THEY MAKE
YOU UNCOMFORTABLE? AND
WHY IS THAT?

Kenneth Marshall

I think a short answer I could give for that, without offending nobody, is that there's no more reproduction. I mean, that's the end of the black race if we had all gay people. I mean, there's no reproduction.

Christopher Briellard

I'm pretty open. The only challenge that I would face is to establish boundaries. Whatever makes your boat float, that's all good. But just know that I don't get down like that. And besides that, I don't really see any problem. I'm very open to everybody. Life is life, and like I said, whatever makes your boat float makes your boat float. I love all my blackness.

Johnnie Muhammad

I do have a deep belief that to be gay is not something that the creator wanted us to be. I don't think that it's a natural way of life. I don't think that it's a way of life that He would be pleased with.

E. Patrick Johnson

Black men loving black men is *the* revolutionary act.

I have no problems with being openly gay in the black community. I live in a predominately black community. I grew up in a predominantly black community, and I've never been in a black community that didn't embrace me. It's a bad rap that the black community gets about being more homophobic than white folks. I think homophobia is homophobia, and you shouldn't quantify it.

Rich Cockrell

Personally, I try to embrace everyone. And I'm not just saying that just to be saying that.

I really do. And it's been a struggle for me to engage homosexual men in general, because a lot of time they think that you're available to approach. No matter if you've identified yourself as being a straight male, they think that you're easy to bring over, if you will. And those guards sometimes are kind of brought up on occasion by the aggressive nature—on occasion by some homosexual men. And so for me personally, a lot of it has to do with how I'm approached as a straight male by the gay community, and them respecting my heterosexuality.

Frank Greene

I can just speak for myself. I'm not putting a lot of energy at targeting anybody, whether I agree or disagree with your sexual preference, and I have a number of gay friends, both black and white. So I'm not putting a lot of energy into that. I think your question may be more from the fact that the media may be putting a lot of energy in—a lot of negative energy—into it and making you feel like it's a message coming from other black folks. I can't speak for everybody, but I'm just saying that I'm not putting a lot of energy into having a negative feeling or a negative intention toward anybody.

Keunthi Davis

I have nothing against gay people. I'm not gay but, you know, everybody loves somebody, and if who you love happens to be the same sex, I have nothing against that. I don't exactly support it, but you have to live your own life.

Nathaniel Manning

I mean, me, personally, I'm not really intimidated or feel like I'm compromised by being in the presence of a gay brother. To each his own. Just from my experience, you know, growing up, it was always taught that to be gay was wrong and there was no other way of thinking of it. But as I grew and got a chance to interact with people of different cultures, different beliefs, different sexual preferences, I was able to accept people for who they were and not who I wanted them to be.

Anansi Knowbody

I'm not threatened or scared or have any fear from black gay men, or any men, in general. I do not like to be confused with gay men. Like, I don't like when people mistake me, if I dress proper or wear more formfitting clothes. I don't like to come off as being gay, and I don't like to be confused within that paradigm. I don't have any problems with anyone else's desires, how they live their lifestyle, but I don't want any misconceptions or anything to be misconstrued.

Malik Yoba

People get really disturbed when they see me do this particular type of character because they feel like, Damn, you do that too well. So I think that as far as sexuality is concerned, I think sexuality is as individual as a fingerprint. I grew up in a household with a homophobic father. I grew up in a community where homophobia was rampant. And I think even as a kid, until I got older and had friends that I paid attention to their journey, did I become more sensitized to what does it feel like, or what does it mean to feel like you may look a certain way or have certain proclivities that maybe don't line up with what people think is a society norm. I just think it's important to live and let live. I'm not really interested in trying to steer somebody away from something that feels so natural to them. I have too many friends—gay, lesbian, transgendered. I know people who have even been born hermaphrodites. I just think that God doesn't make mistakes, and so people will debate this probably forever. Some people will think it's wrong, but I really try to live my life without judgment. So for those of you who may feel you're judged by family or friends or society, one of my favorite things that I like to say to people who think they can judge me is, I say, "What you think about me is none of my business."

HISTORY & POLITICS

BLACK MALES IN AMERICA

ERIC
McNEAL

Q:

WHAT ARE YOUR
THOUGHTS ON HAVING
A BLACK PRESIDENT?

Andalib Khelghati

I didn't believe we could have one. I'll never forget the day after the election, walking into my school and seeing the joyful faces of students.

Eugene Varnado II

They'd say, "Little Johnny, when you grow up, you could be president." But for little black boys, we'd think, yeah, that's not a reality. We have a black president. Everything is possible.

David Lemieux

I don't think that I feel any different now that Barack Obama is president.

Lester N. Coney

And the fact that he's married to a sister, and has two beautiful young daughters, I mean, that's a home run.

John Hope Bryant

That has to fill you with pride. On the other hand, I'm not black for a living. President Barack Obama is not going to come raise your children. President Barack Obama is not going to make your mortgage payment. President Barack Obama is not going to save your life.

Tyrone Dangerfield

Yes, you can be president. Anything is possible, even in this country.

Anansi Knowbody

Just because we have a black president doesn't mean that anything has really changed, or people's perceptions or misconceptions have been altered.

Guthrie Ramsey

He has what it takes. I don't agree with everything—as a black man—with everything that he's done. But guess what? I've never met one black man that I've agreed with everything that he's done.

Johnnie Muhammad

Black men face challenges, the same challenges that we faced before we had a black president.

Darryl Norton

You still have to do what you have to do—as a black man or a black woman or a black child—to succeed.

Reverend C. Herbert Oliver

We should not look to Obama to solve the problems of African Americans. That is still our problem. We have to solve them, and get him to contribute to it.

OMARR FLOOD

Q:

I BELIEVE IN PTSS: POST-
TRAUMATIC SLAVE SYNDROME.
WHEN YOU LOOK YOURSELF
IN THE EYES, IN THE MIRROR,
WOULD YOU CONSIDER
YOURSELF A FIELD NIGGER
OR A HOUSE NIGGER?

David Lemieux

Well, funny you should say that, brother, because I don't believe in Posttraumatic Slave Syndrome. I believe that black people suffer from Perpetual Traumatic Slave Syndrome. That being the case, sir, I'm a field Negro.

Gregory A. Stanton

To put myself in either category would be quite different. I can identify with each at some point in my life. I'm a hybrid right now, the go-between, the one that's the ambassador back and forth from the field to the house and working to keep the connection between the two. Not isolating—that one is better than the other—but realizing that we have a common issue that we're dealing with. Not just that being in the house is better than being in the field, but instead that we're both in a predicament.

Mike "Killer Mike" Render

Wow, a lot of nigger questions for the rapper! I don't know if I believe in Posttraumatic Slave Syndrome in the same sense that you do. If that means there are a group of bad habits such as eating fatback, or others such as self-doubt and unwillingness to be self-reliant, or other bad habits such as an inordinate distrust of power and education and systems that control us, yeah, I believe that we incorporated a lot of things that are unhealthy to us. Is it some spooky syndrome that we need to go to a psychiatrist to be healed for a few sessions? Nah. I don't know. I think it's something that hard work and perseverance could overcome. When I look in the mirror, I don't see a house or field nigger. I see a nigger trying to survive. And based on that, whether I'm in the house or the field, my objective is to kill the master, burn down the house, and get to freedom.

Brian J. Winzer

Well, I look myself in the eye, I gotta consider myself a nigga period, because of what I've been dealing with, the ignorance of what I've been doing to myself. Field or house is not an issue for me. The fact that I've been doing the work of an ignorant nigger is the issue with me, and change is what I promote.

Kalup Linzy

I feel like I'm probably a house nigger on some levels. I'll never forget, my grandmother told me when I was in high school—when I was in all the newspapers and stuff—she always told me that I would do well because white people love me. That came out of her mouth, and I was around black people. I grew up around black people, and I wasn't trying to be anything I wasn't.

Yusufu Mosley

Well, contextually I would say I'm a field hand. I don't say the full word because I think it's denigrating and disrespectful for me to repeat something else that someone used to describe me. In Malcolm's terms, I would be in the field. I would be the one who was wishing that the house would burn down or that a breeze comes along and hurries the fire along. But I would consider myself a field Negro.

Julian T. Roberts

It continues to be the question that we associate our history, our origin, our present being with the slave period. It is part of the indoctrination we received. But if I answer that question within the context, I'm definitely a field nigger . . . who knows the house [laughs].

TONY SNOW

Q:

AS A BLACK MAN IN AMERICA, DO YOU FEEL FREE? I GUESS IT'S TRUE THAT THE FOURTEENTH AMENDMENT GAVE US LEGAL FREEDOM, BUT AS A BLACK MAN IN AMERICA, DO YOU REALLY FEEL FREE—WHEN YOU'RE DEALING WITH THE ECONOMIC RESTRAINTS, AND ALSO THE MENTAL RESTRAINTS, THAT ARE PLACED UPON YOU?

Joel Brown

Do I feel free? That's a pretty deep question. I do now. I haven't always felt that way. I think that once you let go—once I let go—of some of the ideas that someone else was doing something to me or someone else had control over my life, I realized that I influence what goes on, and I have the power to effect whatever change I want. And I started making decisions based on my personal beliefs instead of what a group would say or what my parents thought or what my friends thought. Then yeah, I feel free.

Danny Simmons

The question is, do I feel free? Creatively, I feel free. I think that there are many, many barriers that I've faced that people of other races haven't faced. And if that defines freedom, whether something's put in front of you that impedes you getting somewhere, if that's a restriction of freedom, then maybe so. I think that one of the things that has happened, because of that restriction, is I've found more creative ways to achieve my goals. So I feel like there's been a lot of restrictions, but I don't feel like I'm not free.

Malik Yoba

I find it interesting as I get older how many people allow their internal monologues to dictate their paths toward negative results. So people often talk about what they can't do because they're black, or because they're poor, or because they don't come from the right family, or because they don't live in the right place. The older I get, the more I can attribute it to the freedom that starts here [touches temple]. No one's going to give me freedom, even if the world is saying something different. Particularly for those of us that live in America, because if we travel the world we see that we have a lot more blessings and opportunities than most people, particularly people in developing countries. So I think we really have no excuse but to own a sense of freedom, own a sense of possibility, to own our future. And it's not easy, but we can only live one moment at a time. So I think it's also important to be free from thinking too much about the past or thinking too much about the future. But thinking in this moment as you sit here and you watch this, as you listen, as you think about your dreams, what are you doing in the moment to actualize? And I think if you do that consistently, then you'll be able to experience great freedom.

In terms of myself and my personal being and the way that I operate in the world, I feel free. I feel like I've achieved a sense of personal freedom. But in terms of my relations with other people, in terms of my relations with white people, in terms of my relations with other black people, do I feel free? No, because I constantly feel like there are things that are expected of me, things that are thought about me. I feel as if constantly, especially since I'm an educated black man, that I am perceived as a threat constantly. So when you're asking that question you have to get at the difference between a personal state of freedom and actually being free in the society, and I don't think that we're free in the society. But the funny thing is, I don't think that anyone is. I really wonder sometimes if anyone really can be free. I mean, is freedom really something that we can achieve?

Ronald Porter

YASHUA KLOS

Q:

MY QUESTION IS FOR BLACK MEN WHO ARE, IN ONE
WAY OR ANOTHER, TOO CLOSELY AFFILIATED WITH
THE AMERICAN LEGAL SYSTEM. DON'T YOU REALIZE
THAT BY BECOMING CAUGHT IN THIS SYSTEM, AND
BY ENGAGING IN THE ACTIVITIES AND WHATEVER
BEHAVIOR THAT LANDED YOU IN PRISON, THAT
IN FACT, YOU'RE ACTUALLY FALLING PREY TO A
SYSTEM THAT'S DESIGNED TO KEEP US TRAPPED?
IF YOU REALIZE THIS, WHAT ARE YOU GOING TO DO
TO CHANGE YOUR BEHAVIOR AND STAY OUT OF THIS
SYSTEM? THAT'S MY QUESTION.

Charles Hollins

I first have to have the desire to change and focus on the impact of my violence. The things I do know that are affecting my community, once I know that and I'm empathizing with that, I'm really saying, I'm fucking up my community. I fuckin' cuss. I'm sorry. I'm tearing down my community. I have to have that desire, man. That's just straight to the point. I do realize that I am prey to the system, because the system is designed to keep me down as much as possible. But I also have to make the decision, like, you know what, I'm not going to give them the ammunition. Even though it's designed to keep me down, it's my decision to let it keep me down.

So I really have to look at, what have I done to tear it down, and build it back up—my life, as well as my community. And not let it take advantage of me, even though it's designed to tear me down. Find a way to fight back.

Yusufu Mosley

My brother . . . ooh. I was in prison in this state for twenty-two years, seven months, and twenty-two days. I forgot how many hours. But let me tell you something. I went in as a thinking person so I didn't come out as an unthinking person. I didn't think society owed me anything, but I do think that I owe me something. And that raised my consciousness. My motto of anyone who was in prison was the beloved master, brother minister Malcolm X. And learning from him, and not being bitter, or seeking things that were impossible, I decided to transform society and myself in the process. It's not an easy process. It's not an overnight process. It's a process, and you have to keep thinking. And once the brothers and sisters also get out, we have to make it possible to be safe and to hold them accountable for the wrongs and the harms that they've done brought to our community.

Nathaniel Manning

The cycle is very vicious. Just going and seeing the corner, seeing everybody there, being respected, and— you just want to be respected. That's how you start. And once you go to jail, you're probably a young man that had a family or got some people that you take care of, that you want to see out of this bad situation. So you start accepting the fact that you're going to jail and you're going to do some time because you were trying to take care of your family. There's a point in my life, in my personal experience, when I was just done. There was no way that I could be there for my family in jail. Let's just be realistic. I want to be there for the family, but I'm in jail. So now I'm writing letters back to Mom, who probably can't pay the rent and the lights and all of that, to send me some for soap and toothpaste and all of this. How am I there for the family? It comes a point when you realize if that's your point, what you were trying to do out on the corner, in a part of this vicious cycle—and you're just done! And you're going to be there for the family when you make that decision.

Omarr Flood

Personally, me, right, I didn't realize that it was a trap. I had heard it was a trap, but I believe that there are certain things that you have to go through in life to even realize what's going on with them. And based off of this—I'm twenty-five years old and this is my first time being arrested, and I will probably be going to the penitentiary for a while—I can now realize the traps in it. And what will I do different now? Man, a whole bunch, honestly. I can better prepare for the trap. I'm not planning to come back, and at the same time I'm preparing not to come back. And that's it.

CECIL
WILLIS

Q:

WELFARE HAS DONE A LOT TO DESTROY A LOT OF THE VALUES THAT BLACK PEOPLE HAD. YOU KNOW, IT'S AMAZING. IT'S A TRUE SAYING THAT IF YOU GIVE A MAN A FISH, YOU FEED HIM FOR A DAY. YOU TEACH A MAN TO FISH, YOU DON'T HAVE TO FEED HIM ANYMORE.

Michael Robinson

You know, it's just upsetting, man. It's upsetting when you struggle, when you work and you pay your taxes and you pray, you're tired, you get knocked down. This is not for one individual age group. It's not for young folks. There's old fools out there, too. Public assistance is set up for providing food and nourishment. Section 8 is also. You've got all kinds of support groups, but you abuse them, you know, my tax dollars. Get your ass up and work! Everybody goes to work! My mother has been working all her life, my father's been working. I work. My children work—they go to school.

But you have those individuals who wanna rob. I've had two home invasions. Nigger, get up and work! Why do you sell your LINC? Why do you smoke so much weed? Why are you the biggest consumer of all these expensive clothes, but yet you don't have no job? You're not contributing to the system. That's what I hate about niggers. Niggers!

I'm angry because I've got to go up and work. And what I work for, I've got a nigger to come steal it. And why don't they have the respect for my family, when we come into a theater, or a restaurant, they gotta be cussing. They're cussing, and they're using all kinds of foul language, and they're being descriptive of the females, of bitches and hos, you know. Is your mother a bitch and a ho? You have no respect. Respect! R-e-s-p-e-c-t. Find out what it means to you. I know what it means to me.

REPRESENTATION & MEDIA

ETERNAL POLK

QUESTION BRIDGE: BLACK MALES IN AMERICA

Q:

THIS MAY SEEM LIKE A SILLY
QUESTION, BUT I WANT TO
KNOW. AM I THE ONLY ONE
WHO HAS PROBLEMS EATING
CHICKEN, WATERMELON,
AND BANANAS IN FRONT
OF WHITE PEOPLE?

Delroy Lindo

[Laughing] I don't have a problem with it. Period. I've never heard the bananas one. Bananas, really? Huh.

Rich Cockrell

I'm going to be honest with you. I don't even eat watermelon—because of the connotations it has—around black people. But I will eat some chicken, though.

Charles Hollins

I don't know if you the only one, but it is not a problem for me to eat whatever I want to eat in front of anybody.

Julian O'Connor

No! I know plenty of African Americans who, as a rule, will not eat watermelon in front of white folks. Now for me, I have difficulty relating to the question only in the sense that I've never, ever liked watermelon, and I don't eat meat. So I don't find myself in the situation where chicken and watermelon comes to a head. But I do know that there are times when you feel like you are the stereotype because, you know, if they say, Hey, do you want to go play some basketball? And, of course, I love basketball and I played it every single day, but there's a part of me that wants to say, No, I don't want to play any basketball. What makes you think I want to play basketball? But in those moments I think we have to be honest with ourselves and just know that there are some things that are true. Yes, we like chicken and we like watermelon. There's nothing wrong with that, and there's nothing to be ashamed of.

Corey Baylor

It's not a silly question, brother. My family sells fifty thousand pounds of watermelon every week in the streets of south Chicago, Milwaukee, and Gary, Indiana, and has been since 1953, and we're okay with that. And by the way, I like fried chicken. In fact, I'm going to make some tonight.

Kalup Linzy

I don't know if you're the only one ashamed. I'm not ashamed, but I do give chicken a second thought sometimes, even when I mention it. But I always pass it off as sort of in a jokey-joke way, because I do love chicken. Watermelon? I don't eat watermelon so much, so I'm not really so much ashamed of it. Bananas?

I hadn't thought about bananas because I always think about a banana—because I'm gay—in a sexual way. So when I peel a banana I'm always self-conscious in front of anybody because of sexuality, but not because of race.

Abel Habtegeorgis

You're not the only one, brother, to be honest. Every time—I still eat chicken, I eat a lot of watermelon, and I love bananas—but I'm always looking over my shoulder, wherever I'm at, seeing who's watching me eat this watermelon and this piece of chicken and this banana, always. You're not the only one.

Danny Simmons

I think really that question leads to a deeper question: why are we so concerned of what they think about us? That's what the real question is. I don't really care. You know, I know somewhere in there I do care, but in my consciousness and what I'm going to say, I don't really care what they think. You know, I don't need their approval in order for me to go ahead and be me, or in order for me to do my job, or in order for me to be who I'm going to be. I don't need their approval, I don't need their job—none of that.

I think it's really important that we stop worrying about what they think and start worrying about what you think about yourself, and maybe what the little black kid next door to you thinks about you. Fuck some white person and what they think about you eating a watermelon or anything else—your shoes, your jacket, your hat backwards. I don't go with the sagging pants, but you know, whatever you're doing is because it's your cultural identity. Order your food or whatever. What they think about is not really important.

GIRARD
MOUTON III

Q:

I HEAR SO MUCH, SO MANY OF YOU USING THE RACIAL SLURS, AND YOU KNOW WHAT WORD I'M TALKING ABOUT. IT'S VERY SERIOUS. WE HAVE TO STOP USING IT. COULD YOU IMAGINE YOURSELF GOING TO CHURCH AND HEARING THE PASTOR USING THAT LANGUAGE ON THE PULPIT? COULD YOU IMAGINE MARTIN LUTHER KING MAKING AN ADDRESS USING THAT WORD CONSTANTLY?

WHY DON'T YOU STOP?

Reverend C. Herbert Oliver

When the white person says *nigger*, he really means, in my judgment, to demean the person he's calling by that term. When black people use it, it is sometimes used the very same way, and that is not good. But it can be used in a loving sense, a tender sense. It can be used when people understand each other and when they know that that word is not designed to degrade or to negate one's personality. We also have to realize that there are niggers in the world, and by that I mean people who'll take you for all that you've got, who will not respect you, who despise you, who hate you, and call you *nigger*. Don't think that you can think away niggerhood. It's very deep here, and you had better recognize it when it faces you. If you're not able to recognize niggerhood in people, then you are going to be a victim. So getting rid of that word does not get rid of the reasons for that word, and it doesn't get rid of the concepts that go along with that word. I could wish that the word could be done away with, but it can't be done away with. It can be turned into an endearing term.

I heard Martin Luther King using that—and in fact I have him on tape using that word, but everyone understood him. He was saying, if we do this to challenge segregation boundaries in town, then these white people will be saying, What's wrong with these niggers? What's got into these niggers? Well, everybody understood that. But he wasn't calling people niggers. He was saying that's what they would be saying about these niggers, and that's what they were saying: "These niggers is crazy."

Jamal Johnson

I think it's bullshit that black people can't say *nigger*. I love saying *nigger*, and I think it's fantastic. First of all, it's one of the most beautiful words you can use in the English language because it can express so much—much like the word *fuck*. You can't give white people magic power over us with a word. You know, if we stop saying a word because white people use it poorly, that's an absurdity, and it also gives them much more power than if we used the word freely and just enjoyed ourselves with it. Being caught up with the history of the word, being caught up in whether or not you can use it, or thinking that it's not polite, or that white people might hear you use it, it's all fucking bullshit, and it's a waste of your time. We have much bigger issues.

Malik Yoba

My brothers, my brothers, and so the question is, why do we keep using the N-word? What, new? What is it, nookie? What N-word? What is my opinion about it, the N-word? I think I got to use it. I do. I'll talk to my son, he's eight, and I'm going to ask him not to use it. Maybe we'll stop with the next generation. I'll get back to you on that one . . . nigger!

DWAYNE H. ADAMS, SR.

Q:

WHAT'S WITH THIS CODE OF THE STREETS? HOW
CAN YOU DO A CRIME FOR OTHER PEOPLE AND YOU
TAKE THE TIME? YOU'RE DOING TIME IN PRISON, AND
THESE SAME PEOPLE ARE NOT COMING TO VISIT
YOU OR HELP YOU. IS THE STREETS GONNA HELP
YOU GROW AND HAVE A FAMILY? IS THE STREETS
GOING TO HELP YOU SURVIVE WITH EMPLOYMENT?
IS THE STREETS GOING TO HELP YOU DO ALL OF
THESE OTHER THINGS, OR ARE YOU GOING TO HAVE
TO LOOK AT THINGS AS AN INDIVIDUAL? 'CAUSE IT
DOESN'T MAKE SENSE TO ME.

Charles Hollins

If I get shot, and I take a bullet from somebody else, it's not my purpose to go tell on that person, for the simple fact if I done some of that nature, I'm gonna die anyway, because they beliefs. That's a trip, right? 'Cause when you ask that question, my car been shot up. Yes, in fact, I know who did it, but I didn't tell when the police asked me to. For what? To me, I felt, I say, Hey, the streets will take care of that. And that's just how it is for me. Man, that's just being honest.

Kenneth Marshall

Well, I think it's because it's the us-against-them mentality. Even though we're killing ourselves, we still look at the police and authorities as the ultimate enemy. Therefore, when something happens within our community, we still feel that we shouldn't turn ourselves over to the true enemy.

Jermayue Edwards

If you don't plan on being in the hood, then I guess you don't have to live by the code of the streets. But the code of the streets is something you definitely want to pay attention to, because if you get to snitching or talking, then, you know what I mean? You're dead. So, point blank: if you ain't gonna be around, not planning to be around, then I wouldn't advise you to go by the whole code of the streets. But if you're on the streets all day, every day, then you need to obey that, straight up.

Ivan Montgomery

I guess I could say about that, they've got a code of, don't snitch, no snitching. Keep it real. But if you think about it, man, where do they put the rapists and the killers and the thieves, right? They put them in the same neighborhoods as the people who keep it real, that don't snitch. So if you love your family, love your family, man, how could you continue to keep it real? 'Cause that's where they're putting the killers, the rapers, and the molesters—right next to the people who keep it real. So yeah, that's crazy.

Julian O'Conner

The code of the street is something I reduce down to its most essential element, and that's the rules of the playground. We had simple rules, like you had to be loyal to your friends, you didn't tell on somebody, and you tried to be fair. They're good for a certain point in life, maybe when you're younger. But as you get older and you start to understand that life is more complex, you realize that you have to have a relationship with the police. You have to have a relationship with all of the actors in your community, so that you can get the best results for your community. Committing to the code of the street would be the same as an adult committing to the idea to run their life by the simple rules of the sandlot.

SEAN
LEAKE

Q:

HOW COME MORE OF US DON'T SURF?

Jermayue Edwards

All that water ain't no place for a black man, period. Point blank.

Keunthi Davis

Black men don't surf because to us, it's just not what black folk do. Black folk mostly play basketball or baseball or something like that. Because in most cities we don't have no water where we can get up and surf, like people in Hawaii.

DeMario Patton

I don't surf because I don't know how to swim.

Danny Simmons

Yo dude, I don't surf because I'm scared of drowning. The rest of them? I don't know.

Kalup Linzy

I'm not going to surf because I'm too scared of drowning.

Jamel Shabazz

I think it's a matter of time, there's no doubt, because we've got young brothers skateboarding right now, taking it to the next level. So surfers beware, because I think, brothers, it's just a matter of time. South Beach, here we come.

Corey Baylor

Unfortunately, we can't all grow up in California or the coast of Florida. But for those of us like myself, who grew up in the Midwest, we can skate[board]. I rode a Lester, too, could do 360s on the half pipe, cherry pickers, rock walks, all of that. And I was good.

ANTHONY TROCHEZ

Q:

HOW DOES BLACK MEDIA REPRESENTATION AFFECT YOU?

Dr. Howard Dodson

Everybody knows who and what you are, what you should be, and what you can be. They're running that crap at you. Running at you every day, twenty-four seven.

Broadway, as we know Broadway, gained its position as almost the national theater district around the minstrel shows that were put together in the nineteenth and twentieth centuries. What is it in the consciousness of white people that makes them need to have these kinds of images of black people in order for them to feel good about themselves?

Malik Yoba

If you use, for example, a show like *New York Undercover*, which was a very popular show, there were important things for me, as an actor, to portray on a show like that. I would hug my son. I would have him kiss me. I would kiss him. If the props department said, or if the script called for, you know, "J. C. is sitting in the house while G. is doing his homework watching television"—this would actually be scripted—and I would say, "This is absolutely not going to happen." In fact, I'd tell the props department to go and get books and fill the space with books, whether it be a table or if he's sitting on his bed, surround him with books just to portray that image. I was very conscious of little, subtle things like that, that I understood were impacting millions of people around the world.

Jesse Williams

You know, who's more influenced by pop culture and media than children and adolescents and teenagers? We are at our most vulnerable states, and we're sponges to all information. Now it is also our lens to the outside world, which is therefore our lens to what's attainable for us in life.

White people are everything in media. They cover all bases. We see them holding, holding and succeeding, in all jobs. So when Timothy McVeigh blows up the— when the Oklahoma City bombing happens, it doesn't affect white people, it doesn't change the way they have to live their lives. They're not then profiled for it, because there are 370 other representations of them in the media. And that is the media, by the way—like, news is media. It is all written and affected and manipulated. These are these things we call truths. So yeah, it matters. The way we are represented in media matters.

CHANDLER PARKER

Q:

ALL RIGHT, COOL. SO THIS IS MY QUESTION: I'VE GOT A LOT OF BROTHERS IN THE HOOD LISTENING TO RAP MUSIC, AND I WANT TO KNOW, WHAT IS SO COOL ABOUT SELLING CRACK? COULD SOMEONE TELL ME THAT? I MEAN, WHY IS THAT SO GLORIFIED IN THE MUSIC AND IN THE THINGS THAT WE TALK ABOUT?

Elijah Smith

You asked me, Why is crack so cool? To me, crack is whack, but most people my age, where I come from, in my community, might think it's cool because you can make money, you know, you can really just sit on your butt and make some money. You don't really have to do nothing except you have to watch for cops and be paranoid. And then if a person wants to get out, it's so much of an addiction a person might give it up for a minute, but then you're always going to come back. I believe selling drugs is just as much of an addiction as the person that's using it. You know, you see that money, you get a high.

Brian J. Winzer

Well, as for myself, well, when I came up, crack was a quick way for a black man to make a million dollars. I'm forty years old. In '85 when the crack scene hit, I was fifteen, sixteen years old, watching two parents work dog-hard to death, watching the dude next door who was selling crack ride in big cars. To me, I thought that was cool. And once I learned how to sell crack and learned how to acquire my own money and learned how to have things white folks was having and get up when I want to get up, to me, that was cool.

Nathaniel Manning

I don't think it was the crack. I think it might have been the car that crack bought. It might have been the girl that the crack allowed you to have, to take care of, and that was all we knew. Standing on the corner, what kind of entrepreneur situations or opportunities do we have, other than selling crack or heroin? So I don't think crack was cool. We knew it was killing, but at the same time, it put us in a situation where we were ahead of the pack, so a lot of people get that cloudy vision. Hopefully we can keep this dialogue going, help brothers out and understand that you can't step on somebody, man, to make yourself look good.

Vonteak Lee Alexander

Ain't nothing cool about being out there, taking life chances, standing on my corner, not knowing what's going to occur in any given minute, trying to get some material possession. Ain't nothing cool out there, man. Man, oppressing my people because I'm hurt, hurt people, hurt people—ain't nothing cool with that. Ain't nothing cool with me selling crack to my mama, taking the Christmas toys away from my little siblings 'cause I'm charging my mama one hundred dollars for a dime on credit. Ain't nothing cool knocking my daddy out because he stole my bundle, my bundle of crack, that is. Ain't nothing cool with me taking my sister to go prostitute on the track to get some money because what? Because I didn't have that childhood that society supposedly wanted me to have. Ain't nothing cool with selling a pregnant woman crack, man—nothing cool at all. Ain't nothing cool for me to sit here and have to subject myself to such harm because I want a future. I want a better life.

Ain't nothing cool with that at all, because, man, I got an answer for everything I do, for my actions and inactions, and I been a part of bullshit. And I didn't see it on the streets. I was blinded to what—that delusion of grandeur, thinking that I'm greater than life itself? And I wasn't. You feel me? I'm responsible for the hell and hurt that I done caused people, all those broken families out there. I'm responsible for children that's incarcerated right now, as we speak. I'm incarcerated for death out there based on me selling crack, because I never knew what a person had to do to go and get it. You feel me? I'm responsible for that shit. Ain't nothing cool with that, and at nighttime I sit and I sleep in my cell, man, and I sit there lost in thoughts, man, damn! When nightmares start to arrive, like, Teak, you fucked up again. I fucked

up, I didn't know what I was out there doing. But I did, because it was the green, the money. You feel me? And now . . . How am I going to feel when someone sells my son some crack? You feel me? How am I going to feel when my wife gets older and somebody sells her crack? Shit, man. It ain't cool.

It ain't cool at all. I mean it. Everybody got to pay for what they've done, and this is a form of me paying for what I done out there to that community, man, because it goes deeper than crack. It goes back to all them little kids who seen me out there and I didn't take time to talk to them or let them know that they are loved. So we're talking about substance issues. It's deeper than that substance. It's a genuine courtesy of just telling someone, man, you are loved. I am responsible for a lot of things. Ain't no answer for that, man. I'm just sitting here with the bullshit I created. I just watch my people sit here and cry. Babies, crack babies—that's in the womb, that's unborn, that's undeveloped, missing one ear—I'm responsible for that shit. I'm responsible for everything. I hold myself accountable. Shit. But I been committed suicide a long time ago when I was part of that bullshit. Now I claim my life. I'm a part of something that's greater, and that's the solution.

SHAUN CHAPITAL

Q:

THIS QUESTION IS TO YOU, THE MEMBER OF THE
OLDER GENERATION. THE OLDER CULTURE SEEMS
TO FOCUS ON A LOT OF THE NEGATIVE—OR WHAT
THEY PERCEIVE AS THE NEGATIVE—ASPECTS OF
OUR CULTURE, WHETHER IT BE THE DRESS, THE
MUSIC, THINGS OF THAT NATURE. IF YOU TOOK
A STEP BACK, WOULD YOU REALLY SAY THAT THIS IS
THE PROBLEM? IS IT THE MUSIC? IS IT THE CLOTHING?
IS THAT THE PROBLEM? OR IS IT A BIGGER PROBLEM
THAT MAYBE STARTS IN YOUR GENERATION?

Ambassador Andrew Young

Well, you're probably right. It does start with our generation, but it ends in yours. And you have to take responsibility for it. The problem I have with dress and the music is that it is a symptom of the unfinished business of my generation. You're supposed to be dressed and acting like you're not still suffering of the shortcomings of our society. You're creating a new society.

Jabari Mahiri

Every generation has its own set of imperatives that it's attempting to deal with. And in my generation I'm sure my parents were just as surprised by the ways that we chose to represent: big Afros, Maoist suits, dashikis. And even to this day I haven't seen anything more radical in a way of dress than hot pants. So that was out of my generation!

Darryl Norton

It's funny that you would bring up that question 'cause oftentimes I work with kids and I see them with their pants hanging all the way down to their knees and everything, and their underwear showing, and stuff like that, and I kind of equate it with when I was in the '60s. I had an Afro, which I would say was about three feet high, and every time the wind blew I could barely stand up straight. And everybody did. And the older generation at that point was very upset, but it was a form of our protest against the kind of apartheid-like issues that we faced during that time.

To this generation, though, one of the things that I, as a black man, see is those types of things negate the struggles that I went through in order for you to be where you are, to express where you are, and that your expression is not something that I would consider to be helpful to you getting forward in life.

A dear friend of mine once said that our children are the poets. They are the picture of what we have produced. They are the result of what we have done and what we have failed to do. And I believe that. I believe our children are. And the second part of the statement was that we, as the adults, don't like the picture that they have brought back to us, so we condemn them and condemn the picture rather than realize that they reflect what we have done and what we have failed to do as a generation of adults. So the solution to the problem is twofold. I don't believe that we ignore what we see to be problems with our young generation. We can address that. But we have to give them creative outlets. We have to give them positive and constructive things to do. So the adults have that responsibility. But the young people have to have an ear and a heart to receive what we're putting out there also, when we do provide the positive pieces that they can incorporate in their lives. So, not an easy answer to the problem that confronts us, but I believe an answer that we can address nonetheless, if we address it on both sides of the equation. I hope that answers your question. Be blessed.

Edward Morris

QUESTION BRIDGE

LAST WORD

BLACK MALES IN AMERICA

MUSA HIXSON

Q:

THE MOST IMPORTANT QUESTION THAT I HAVE IS
FOR A PERSON THAT HAS SIMILAR EXPERIENCES
AS MINE: A BLACK MAN, MAYBE SIMILAR CULTURAL
ENVIRONMENT. WHAT TYPE OF DAILY PRACTICES
DO YOU HAVE TO, YOU KNOW, KEEP YOUR RESOLVE,
KEEP THE FAITH, MAINTAIN MENTAL STABILITY, AND,
YOU KNOW, TO CONTINUE TO PROSPER IN YOUR
ENVIRONMENT?

Frank Greene

Well, I have maybe one basic answer. I mean, keeping in mind that I grew up in Washington, D.C., in the '40s and the '50s—in the '40s, and then moved to St. Louis in the '50s and the '60s, and lived there in very segregated environments. And one of the things I learned, especially from my mother and father—and I was fortunate that our family was pretty much intact—is that you really need to set goals, and keep focused on where you want to go and what you want to do, and keep learning. And so that's what I do every day. Every day I look at as a learning experience and I try to reflect before I go to bed at night, Okay, what did I learn today that's going to help me go to where I want to go? And I always have goals and visions that I'm working on. By staying focused on these goals and visions and what I'm learning, it's been a way that's helped me succeed at a lot of things I've done in life. But it's been basically that process.

Jumaane N'Namdi

So my thing is finding an eternal spirit, an eternal self that's speaking to myself, communicating to myself those different things that I know are good for me. It's as simple as an occasional point forward, literally pointing, like, that's the direction you're going. As simple as that. Somebody else could look at me and think I'm pointing to someone, but really I'm just reminding myself, Okay, this is where you're going, just keep moving, stay focused.

Abel Habtegeorgis

I pray. I pray every day. Right before I go to sleep, when I wake up in the morning, I really pray. I don't mean to get corny with it or anything, but I really do wake up in the morning and thank God that I made it through the night, and at the end of the day I thank God that I made it through the day. It's what my mom told me to do; it's what my dad told me to do. And when I'm looking for strength, those are the two that I turn to as well.

Kevin A. Johnson

I think there are basically three things that I engage in to maintain a sense of personal peace, groundedness. I'm a spiritual person, grew up in church. That doesn't necessarily translate to being spiritual. Over the years I've realized that's an essential part of my life. So I practice meditation, I practice prayer. I practice quiet time where there's no words coming out of my mouth, and I think it's more important to just sit and listen. Sometimes I hear myself, and sometimes I like to call God. And sometimes I hear nothing, and I just rest in that moment. Something else I do is physical exercise. It's been proven time and time again scientifically that when we exercise we equip our brains for us to be more receptive to learning. We put ourselves in a better position emotionally when we exercise, because we're bringing up good stress and eliminating bad stress. The third practice is connection. It's important for me to connect with people and maintain those ties because those ties are mirrors for me. They help me understand where I'm at and if the other practices are doing well. Then I can be in the presence of other people and see the reflection of my practice in them. And it's always a good thing because I can look into someone else's eyes, and they'll tell me the truth, whether I want to hear it or not, about where I am in my other practices. It's helpful.

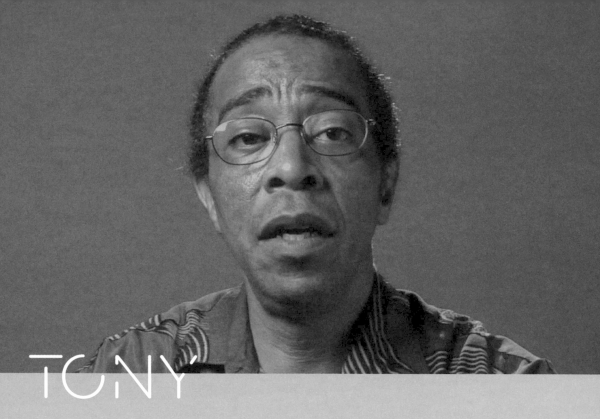

TONY BINGHAM

Q:

MY QUESTION WOULD BE, IS THERE A PERSON WHO, THROUGH WHAT I WOULD JUDGE AS A NEGATIVE WAY OF LIVING—POOR CHOICES, MAYBE LEAVING SCHOOL TOO SOON AND ENGAGING IN ILLEGAL ACTIVITIES—HAS INFLUENCED YOU TO LIVE YOUR LIFE DIFFERENTLY? IS THERE A PERSON LIKE THAT IN YOUR LIFE?

Ivan Montgomery

Yup. I'm that person. When I look in the mirror, man, I see a person, man, that I don't want to be—the person that I used to be. I don't want to be the person that's dishonorable, disloyal, or out of order. Since I don't want to be who I used to be, I grab hold to being somebody I want to be. Because change is not free. Nothing in the world is free. It even costs for me to change from who I don't want to be to someone that I want to be. I got to give up the old person to grab on to the new me. I'm that person. I'm my own example. You know, I'm my own example of who I don't want to be.

Tony Brown, MD

I have to answer that there wasn't one negative person, but rather a negative personality. And it's that personality that responds, Oh great, you got into Harvard? I heard they were letting more blacks in there. Or, Wonderful, you got into med school! I heard they were increasing the quota. It's that attitude that dismisses my long hours of study at night. It's that attitude that dismisses my *improvise, adapt, and overcome* attitude that the Marine Corps had taught. As a matter of fact, the Marine Corps was right. If you want to succeed, it's the seven Ps of life: Proper Prior Planning Prevents Piss-Poor Performance. It's not your color and it's not your lack of color. It's just trying hard to do what you know you can do.

Ethan Richards

Actually, I made those mistakes myself. Twenty-six years old, I just enrolled in community college, got eighteen credits. Actually what influences me now is that a lot of my peers are living that negative life. I don't have a lot of peers around me that are moving where I am moving, as far as attending school, working toward a career. And it's not because they basically want to do the things they are doing, but I think it's lack of opportunity. That influence is really motivation. My peers motivate me to move forward in my career and move forward with my academics and all that. So that's how I'd answer that question.

Tyrone Dangerfield

My father, he influenced me to be a better person. Because when I was up to fourteen, fifteen, sixteen, seventeen years old, like a mirror, I was living the same life as him. False IDs, drugs, selling guns—and that's everything he did. And it was him, not hip-hop, who showed me how to use the word *bitch*. He showed me how to cook up crack. And one day I woke up and said, "I don't want to be this." He died because he . . he was a genius. My father was genius; he had a degree. But he chose to live a Lex Luthor life. He seemed like he wanted to use everything for no good. Creating whatever he could create. As long as it was not legal, he wanted to do it. I didn't want that for my son. I didn't want that for my life. I wanted to live past the age of thirty-three.

Corey Baylor

That's a great question. I grew up with a very good friend of mine—since the fourth grade—who was one of my closest, closest friends amongst a group of other young black boys who had just moved to the suburbs. And life was good, and we had idyllic settings, parks, and great schools. Over time, as we grew older and started hanging out, listening to music, going to parties, my friend was seduced by the darker side of living in the city, and was seduced by the gangland culture of the Midwest in the '80s. Wanted the respect of the homeboys; wanted to live like they lived. And over time, started making choices. Made a couple of very difficult choices. The farther he went down that path, the more of a distinction was drawn between the two ways we were living.

Fast-forward a couple of years, maybe a couple of decades. Life starts catching up with that path. Life started accelerating for my own. And I'm comfortable with that. He probably was, too. In fact we talked about it, and everything was fine when we see each other. But unfortunately, I won't get a chance to see him again. Just this past weekend, two days ago, he was found. Five bullets. In his own business. Now, we'll never know what happened, but we do know that it did happen. And you start asking yourself, where were the diverging paths? And maybe there were several, but at the end of the day, they were identifiable.

Jamel Shabazz

When I was growing up, back in the days, I remember a violent incident that took place when I was about fifteen years old. It was a brutal act that was committed on a girl because she was poor. And it was an after-school fight. I remember these bully girls, you know, they saw this young girl who couldn't get her hair done, and didn't have the latest fashion, and for whatever reason, this female picked a fight with her. And I remember the whole school just was there, surrounding. It was almost like a lynching. And this girl was terrified, and this bully female commenced on beating this female down for no reason other than her being poor. And what was terrible about this incident is that she just wasn't satisfied with beating her down.

She had a dress on—the girl, the victim, had a dress on. And the girl pulled up her dress and somehow she got a broomstick, and she pulled her panties off and she shoved the broom in her vagina. And nobody did anything, and I was young at that time, and I didn't even know what to do. It shocked me. And I said to myself that I would never, ever let that happen ever again in my community. Never will I allow a brutal act to exist in front of me, and I will not intervene. So from that negative experience that transpired over thirty-five years ago, it motivated me into action, to have a desire to bring about love and unity within my community. And that one incident burns in my mind till this very day, and I have committed myself to striving to end the violence and the recklessness that exists within our community.

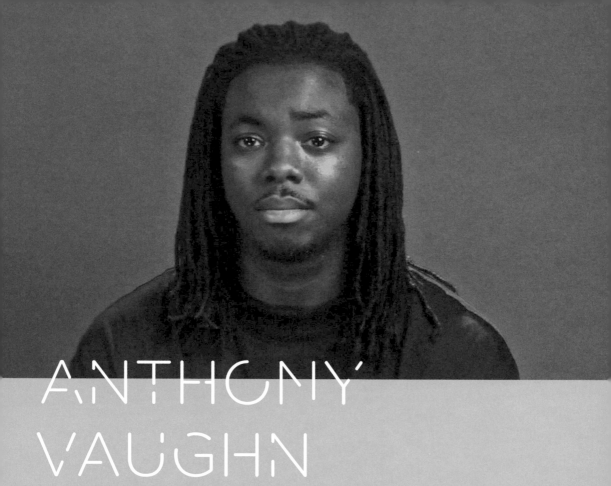

ANTHONY VAUGHN

Q:

ALL RIGHT, MY QUESTION IS:
I TRY TO LIVE GOOD, BUT I'M
SURROUNDED BY BAD. I WANT
TO KNOW WHAT IT IS I COULD
DO TO BE BETTER AND LIVE
PEACEFUL, SURROUNDED
BY ALL EVIL. HOW CAN I DO
THAT?

Jamel Shabazz

Brother, I know it's hard out there. When I was younger, you know, I was surrounded by a lot of negativity, too. I decided to take the road less traveled. I separated myself from a lot of negativity, dropped a lot of my negative ways, took myself out of the community. You know, I got away from the concrete. I went out to the ocean. I went to the library, went to museums. There's a way, brother. I know it's hard out there. The difficulties are everywhere. What I had to do—I had to change it. We were taught that proper education corrects errors, so with brothers that were negative on the street corner, I tried to encourage them. I took a negative and made it a positive. So a lot of those things I didn't like around me—I used my love for my people to kind of change things, and I did, and I was very fortunate.

Kenneth Marshall

First of all, you've gotta stop generalizing and saying all evil, because I'm quite sure that not everything's evil out there. You just have to learn to distinguish between what crowds you want to hang around with and which ones you don't. And the ones you see that have got the same interests as you do, blend or flop toward that particular crowd or something. But to say all evil? There's no such thing as all evil, I'm quite sure.

Brian J. Winzer

In my experience, whenever I tried to live good surrounded by evil, I had to keep putting good inside of me. I had to keep dealing with everything that I knew was good. I had to stay positive. I had to stay prayed up. I had to stay with my faith, because if you have something strong to hold on to at any time, any faith, I guarantee that evil will pass you by.

I think you have to stand up to evil. If you're not willing to stand up and be yourself in the face of death, you're never going to find out who you really are.

Ambassador Andrew Young

The odds are that it's probably more lived good in the world on a day-to-day basis than lived bad, but the perception in the world is dominated by the bad.

Dr. Howard Dodson

A way to stay out of trouble—and there's so much around you—is to find more activities to get into, possibly a job. You feel me? Be your own man. Don't hang in groups. Just follow yourself, man. Listen to your own self. Be a leader, not a follower.

Jermayue Edwards

Anthony, you can live peacefully in this life if you have faith in God. Being surrounded by evil does not take away your faith and your peace, because we are a part of the evil. We ourselves are part of the evil, so we can't get rid of it. But by faith in God, and a God who loves us, and a God who has provided redemption for us in his son, we can have his peace with us. And he promised to give us that peace in the worst of circumstances and in the midst of even death and in the face of death. God's peace can be in your heart while turmoil is raging all around outside.

Reverend C. Herbert Oliver

I understand, young man, that you want to find peace, at such a troubling time with wars going on in other countries, even wars going on in your neighborhood. One way to find that peace is by making yourself peace. It's by having inner peace within yourself first, and then spreading that joy of peace amongst everyone around you. You have to be a trendsetter. You have to be a leader. You have to be a motivator. Like I'm trying to motivate you to spread peace, to be peace, you have to motivate your brothers and sisters. And I'll be there to help you. If you motivate others it will become contagious, and no matter if you're in another country, another state, that contagiousness will spread to where I'm at, and it'll motivate me even more, and we'll be working together. Peace.

Mickyel Bethune

ABEL
HABTEGEORGIS

Q:

WHAT ARE YOU SCARED OF?
WHAT DO YOU FEAR?

Hmm . . . what am I scared of?

Jumaane N'Nambi

Fear of failure.

Andalib Khelghati

Failure.

Delroy Lindo

Failure.

Guthrie Ramsey

Me not being the person that I'm able to be: a man, taking care of his family. Leaving this world without my mother putting a smile on my face.

Kenny Kent

Not being able to protect those I love if they need me to protect them.

David Lemieux

Something happening to my family.

Yaakov Curry

Being put away for a long time and leaving my mom at home by herself, hurting.

Jermayue Edwards

Disappointing my father.

Jesse Williams

My biggest fear ... is a person trying to force their beliefs on me.

Omarr Flood

Jumaane N'Nambi

I'm scared of the dark. Even today, I mean, the moonlight is good, but I will leave a bathroom light on at night.

Keunthi Davis

My brother, I don't think I fear too much of anything.

Morris Brent

I'm not scared of anything.

Guthrie Ramsey

Snakes.

Brian J. Winzer

I used to say I wasn't scared of nothing, but due to the fact that I have been consistently falling down on my face, maybe I'm scared of success.

Armani McFarland

Getting shot.

Julian T. Roberts

I'm afraid . . . that I'm not afraid of anything.

Gregory A. Stanton

I fear most . . . you. You look like me, you talk like me, you are me. But at the same time, it's the enemy within, which is the person who can do you in. And because of all the things going on in society and in our community, sometimes I'm just as afraid of you as you are of me.

TONY SNOW

Q:

YOU KNOW, I WONDER, BLACK MAN, ARE YOU REALLY READY FOR FREEDOM? AND IF NOT, WHAT WOULD IT TAKE FOR YOU TO WANT AND NEED THIS FREEDOM?

Ronald Porter

To be totally honest with you, I'm ready for freedom. But I don't think all of us are ready for freedom. I think a lot of us are not confident enough for freedom. I think a lot of us don't love ourselves enough to be truly free. I don't think freedom is some grand destination that we're trying to finally get to at the end of some long history. I think a lot of us are afraid to be free every day of our lives. I think in some ways we are regulated by being black. I think there are certain things that are assumed and expected of us, not only of white people, but also of ourselves. So if we really want freedom, if we really want to be free, we have to get ready to be ourselves and live unto ourselves. That's the question.

Ivan Montgomery

Am I ready for freedom, and what would it take for me to want that freedom? First, I'd have to stop and ask myself—that's a tough question, because freedom for me is a mind state. You know, because you got some people who's not in jail who's not free. You got people who's in prison in dysfunctional relationships. You got people are in prison with jobs—they work nine-to-five—that they don't like. Some people are in prison with alcohol or drug abuse. So I would have to really ask myself, What's been imprisoning me? What's imprisoning me is my self-esteem, my lack of self-esteem. My lack of self-esteem has led me to commit crimes, to hurt people, manipulate people, right? Because if I love myself there's no way that I could walk outside this room and punch somebody—if I'm esteemed within myself. So to be free to me would be—I would have to change. So in order for me to grow I have to change, because if change is necessary for growth, in order for me to grow I would have to adapt the mentality that something's got to change. I'd have to change my mind state, I'd have to change the way I talk, I'd have to change the people I interact with. That would be free.

MALIK SENEFERU

Q:

WHAT IS THE LAST WORD THAT
WE CAN REMEMBER YOU BY AS
A BLACK MAN? FOR YOUR LAST
DAY ON THIS EARTH, WHAT
IS THE WORD THAT WE CAN
REMEMBER YOU BY?

Tyrone Dangerfield

The last word as a black man that I would like to be remembered by is: warrior.

Jamel Shabazz

Sincere.

Nathaniel Manning

Motivated.

Gavin J. Amour

Dedicated.

Malik Yoba

The proper balance.

Omarr Flood

Family-oriented.

Darrale Jones

Honesty.

Gerald Sinclair

As a student of Bahá'u'lláh.

Brian J. Winzer

He seen the light, and changed.

Jermayue Edwards

Creative. 'Cause if you don't know, man, I'm the creator.

Lester N. Coney

Thoughtful.

Alex Morgan

Responsibility.

Mark Cox

Empowerment.

Danny Simmons

Danny Simmons, artist.

Darryl Norton

Father, I think, is the greatest thing a black man can be. Father.

Thomas Allen Harris

Om.

REFLECTING B(L)ACK

BY HANK WILLIS THOMAS

I guess every person has a day of infamy in his or her life. Mine is Tuesday, February 2, 2000. This was the day I lost Songha Thomas Willis, my cousin, roommate, best friend, and, for all intents and purposes, big brother. He was shot dead, execution-style, in front of dozens of people during a robbery in which he did not resist. The first thing a friend said after hearing the news was, "The worst part of it all is, I don't even have to ask if the killer was black." When telling strangers what had happened, I frequently found myself combatting assumptions that Songha might have been involved in some kind of criminal activity himself. It bothered me how easily people could jump to conclusions based on so little information. That day of infamy was a day of horror, but it was also a day of redefinition. The word *art* means something different to me now. It offers a little bit of hope for answers, or at least better questions. I have struggled for almost eight years to find creative ways to deal with my cousin's murder and the larger genocide of African American males. For me, the problem seems tied to the overall myth of black maleness. The image of the black male created by commercial media and historical suggestion is a fraud. My aim is to expose it.

From 1865 to 1965, over 3,400 African Americans were lynched in the United States. Between 2003 and 2015, over 4,500 U.S. soldiers were killed in combat in the war in Iraq. In 2003 alone, there were

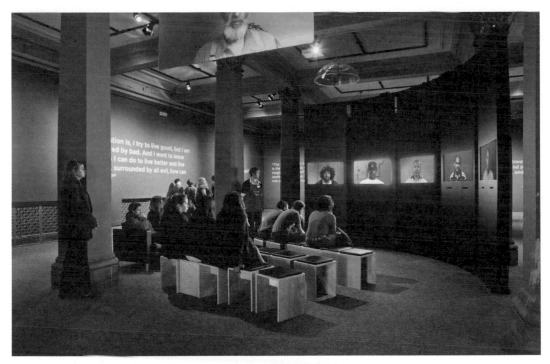

Installation view, courtesy the Missouri History Museum, St. Louis, 2013

6,912 African American homicide victims. Lynching a black man is no longer acceptable. Debates raged over the loss of life in Iraq. Meanwhile, more African Americans were killed at home in one year than soldiers in a foreign war zone over four years. How could this be, and how could so little notice have been paid? This is a critical moment in history for African Americans. The past thirty years have been arguably the most hostile time for black people since the height of the Jim Crow era. They have also been the most economically and socially rewarding. African American men in particular have been especially challenged by this paradox. During the same period that Barack Obama was twice elected president, black men remain severely overrepresented in rates of incarceration, homicide, police brutality, high school dropouts, and various preventable health risks. Furthermore, we have come to understand that most Americans,

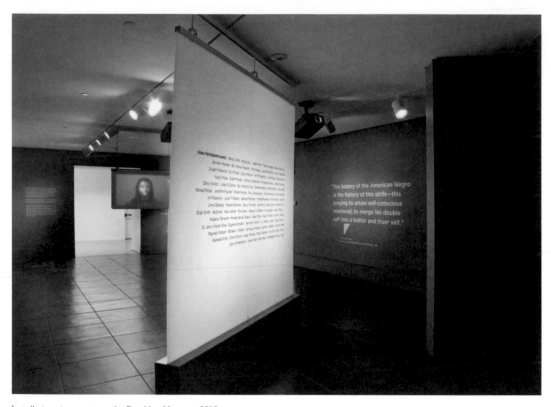

Installation view, courtesy the Brooklyn Museum, 2012

regardless of ethnicity, have an implicit bias against black men. The Supreme Court's 1954 decision in *Brown v. Board of Education* was a profound affirmation of the right we all have to equal access to educational opportunities. One of the most persuasive arguments made by the *Brown* decision is that segregation is inherently damaging to the psychological health of black Americans. If it is true that division and isolation distort the formation of identity, then we have to look closely at what really divides us today. Since 1954, the fissures within the broader African American community have widened painfully. In the wake of desegregation, many black Americans have been able to transcend racial, cultural, and economic boundaries, while others have found themselves increasingly confined

and defined by the struggles of life in inner-city neighborhoods. Still others exist in and across both sets of circumstances. In 1903, W. E. B. Du Bois wrote, "The history of the American Negro is the history of this strife, this longing to attain self-conscious manhood, to merge his double self into a better and truer self." The legacies of slavery, segregation, and subsequent decades of disenfranchisement through convoluted legal and social policies have continued to overshadow the lives of African Americans, yet these distinctions complicate attempts to define what it means to be black in America.

Generations of politicians, activists, and academics, be they scientists, social scientists, cultural theorists, or historians, have investigated the "plight" of the African American male, yet far too little is known about the range of internal values and dynamics contained within this group. Historically, their representation in popular culture has often been governed by prevailing attitudes about race and sexuality. Not enough has been done to find a multifaceted and, critically, self-determined representation of this demographic. The truth is that there is as much diversity within any demographic as there is outside of it. Should anyone be confined to another's definition of who they are? The most dangerous thing about blackness is that black people didn't create it. Europeans with a commercial interest in creating a subhuman type of person that could be traded as a commodity fabricated the concept of a black race. Nearly every virtue or characteristic ordinarily ascribed to human beings was stripped away as justification for the transatlantic slave trade. The residue of this mythology continues to corrode our discourse. Africa is a huge continent with hundreds of millions of individuals, thousands of religions, histories, languages, and cultures. Could such a galaxy of existences be reduced to a single, simple word? The persistent struggle for generations of Americans of African descent has been to turn a concept designed to regulate them into something beautiful and laudable.

Carl Hancock Rux speaks to this idea in his essay "Eminem: The New White Negro" (published in *Everything But the Burden: What White People Are Taking from Black Culture*, 2003):

There is something called black in America and there is something
called white in America and I know them when I see them but will
forever be unable to explain the meaning of them because they
are not real even though they have a very real place in my daily
existence, a fundamental relationship to my understanding of history,
and a critical place in my relationship to humanity.

Rux's articulation of the conundrum eloquently illustrated so many
of the challenges I have faced as a black male artist in the United
States. I also realized that I couldn't find a consensus between any
three black males on what it means to be black and male. During this
period, I learned about an innovative nonfiction video project that
my professor Chris Johnson had piloted to foster open dialogue and
address class divisions in the African American community in San
Diego in 1996. I approached Chris about collaborating with me on
a project that focused on addressing the growing number of issues
that challenge, afflict, and unite African American men specifically.
My hope was that this would be a way to actually get the consensus
I had been looking for. Instead of doing a small documentary project
with Chris, the project grew into a national, multiplatform, transmedia
project, which involved several other artists, teachers, institutions,
designers, programmers, writers, and eventually hundreds of black
male participants. In a way, it became a movement.

Question Bridge: Black Males is comprised of a series of video-
recorded question-and-answer exchanges designed to explore issues
within the African American male demographic. By using opaque
identity containers like black and male, and then creating an outlet
to release the diversity of identities and thoughts inside those
parameters, we challenge the necessity of such containers. Through
this project, we hope to make it more difficult to reduce the agency
and humanity of these individuals by saying, "Black men are . . ." With
this hypothesis in mind, we have traveled across the country and
recorded the questions and answers of over 160 men, ranging from
judges to prisoners, athletes to engineers, fathers to sons, entertainers
to factory workers, ministers to gay teens, recently arrived African
immigrants to ninth-generation citizens. We provided a format for

them to express their concerns, beliefs, and values in response to a variety of questions, all mediated by a camera lens. The questions and answers created by each subject were interwoven during the editing of the project to create a stream-of-consciousness type of megalogue, which attempts to shed light on the complexities of issues that are usually washed over in the media. This project brings to light a more complete spectrum of what it means to be black and male. Blackness ceases to be a simple, monochromatic concept. The purpose of *Question Bridge* is to provide a safe setting for open expression and vulnerability. At times it seems that black males' greatest challenges are with one another. The question is: why?

In a sense, the project is not about black men at all. It's about people. It's about what happens when people are put into groups, and how they relate to the idea of the group and to others within it. This is a human experience. We live in a moment in which we are outgrowing longstanding and authoritative narratives written by our traditional historians or leaders. Nearly every boundary has become permeable. We have a greater understanding of the value of each of our voices and the importance of listening to a variety of perspectives, before forming our own conclusions about a given issue. My greatest hope for this project is that the model and methodology we have created for *Question Bridge* can be replicated and applied to address a broad range of human issues that aren't only race- or gender-specific. This is only the beginning.

THE CONVERSATION

BY BAYETÉ ROSS SMITH

Question Bridge: Black Males was crafted using several principles.
We hoped to create an environment that suggested that a group of
black men were having a conversation together about a wide range
of topics, many of which did not directly relate to being black in
America. This informed the decision to create a five-channel video, in
which the faces change, speak, look, and appear to listen at different
points throughout the piece. *Question Bridge* evolved into being a
transmedia piece—a work that uses multiple platforms to connect to
its audience—out of our desire to create art that would be accessible
to people within the course of their daily lives.

The *Question Bridge* installation was well-received from its
debut at the Sundance Film Festival in 2012, and in other venues
where it has been shown. Aside from direct feedback from audience
members who contacted us, we have also been able to determine
how compelling this work is by the amount of time the audience
spends with it. Typically, video art holds a viewer's attention for a
few minutes. When we put together the final video piece in 2011, we
created narratives within each question and answer, in order for
viewers to feel like they could have a complete experience, with some
sort of closure, within five minutes.

We then built larger narratives between several Q&A sequences,
and then tied those sequences together thematically to create

six sections of the larger video piece. We made the full work approximately three hours long, under the premise that the audience would not watch the entire piece in one sitting. We believed that visitors would watch for approximately five to ten minutes, but hopefully return later and watch additional portions of the piece. What actually occurred when people began watching *Question Bridge* was that they attempted to stay and watch the entire three-hour installation. When the work was exhibited at the Brooklyn Museum, we found it necessary to start screening the video content in the museum's theater at specific times to alleviate crowding, because people were staying in the exhibition space much longer than we estimated. The theatrical version, which is basically the experience of watching the installation in a movie theater, has been a great tool for making *Question Bridge* available in a wide variety of spaces beyond a gallery.

With most nonfiction and documentary projects, an authoritative narrator contextualizes what the viewer is experiencing. *Question Bridge: Black Males*, on the other hand, does away with this convention. Instead, content comes directly from the minds of black men. We, the artists, function as facilitators; though we curated the participants' contributions into a cohesive story, we never influenced what they said or how they said it. We simply organized and sequenced their contributions. This resulted in a candid experience that gives the viewer a window into black male consciousness, by allowing the audience to observe a conversation that they normally wouldn't be exposed to. Both the conversation and the viewer's access to it could not occur without the use of technology. I believe that, as artists, we are capable of working collaboratively with the general public in order to create diverse and inclusive narratives. As media has become its own language, it is important that we all have a role in scripting and speaking it. This means allowing people to shape the images that are often used to define them. With *Question Bridge: Black Males*, we helped our participants actively influence how their narratives are told.

There have been numerous common responses to the work. One we received often is that the viewer was not aware that there were this many different types of black men out there. We realized that many people in our society, even other black people, had not had the opportunity to gaze into the faces of black men and simultaneously listen to black men speak candidly about their perspectives on the world. People who attended who had black men in their lives, expressed that they had gained a new perspective by being able to truly listen and feel comfortable, almost as if they were eavesdropping. One young teenager from Houston told me she felt it was a really special opportunity to be able to be in the "presence" of black men and hear their thoughts, and felt she would never have had that opportunity if it weren't for *Question Bridge*. She said she interacts with black men on a regular basis in very superficial ways, and was aware that media representations of black males often further common misconceptions.

My upbringing shaped my interests as an artist. My mother was a teacher with a PhD in early-childhood education. She was the first member of my family, though not the last, to get a doctorate. From an early age, education was emphasized in my life. This was not, however, education simply for the sake of knowledge, but understanding how to acquire information, process it, and apply it to a variety of scenarios in a productive way. Critical and analytical thinking were both mandatory in my household. My father is a jazz musician who plays the bass. He supplied the improvisation, creativity, and imagination that informed my thought process and worldview as a young man. Most important, they helped me combine art and education, with the understanding that imagining something, and then creating it, could help me grow intellectually. The performance of identity is fascinating to me. As a photographer and visual artist, I have always been interested in how identity is perceived. What I find most interesting about identity is how it is expressed through performance. Every day human beings in all parts of the world dress, talk, occupy spaces, and promote visual and verbal symbols that express who they are to other human beings. *Question*

Question Bridge's education coordinator Samara Gaev leads a curriculum workshop during a Teacher Leadership program at the Brooklyn Museum, 2012. Photograph by Kameelah Rasheed

Bridge allowed me to imagine and rework ideas about performance and identity, which helped me to shape ideas in creating this project based on my own personal experiences. A very important aspect of *Question Bridge* is that it functions almost like a case study. Although we set out to investigate black male identity, it becomes apparent, given the methodology and execution of the project, that the concepts and themes are actually universal and not exclusive to black men. By experiencing this deconstruction of the demographics of "blackness" and "maleness," viewers are able to see our shared humanity that exists beyond demographic labels and check boxes. While cultural backgrounds and perspectives are important, they are also often arbitrary. I believe *Question Bridge* can help all of us see beyond the labels that accompany identity and, hopefully, focus on how we are more alike than different, as well as appreciate what truly makes each of us unique and valuable.

WHAT ARE THE PARAMETERS OF IDENTITY?

EXPANDING OUR CAPACITY TO UNDERSTAND COMPLEX AND DYNAMIC IDENTITIES

BY KAMAL SINCLAIR

Question Bridge harnesses the magnetic power of art to create a tool that forges connection and catalyzes conversation, enabling a demographic to define its own identity in a new, bold, dynamic, comprehensive, complex, and perpetual manner. This particular process could not have been accomplished before the widespread access to technology and social-networking culture, which makes it particularly timely.

I remember the night I became a *Question Bridge* collaborator. I helped Hank, Chris, and Bayeté organize a filming of a number of black men in Atlanta, and asked Dr. Joy DeGruy[1] to host them in her home. At the end of the day, the team set up a laptop in Joy's kitchen and started sharing clip after clip from the more than one thousand question-and-answer videos they had captured. It was astounding to hear so many compelling, authentic, and diverse voices coming from that small screen. Hank asked, "What should we do with this? Should it be a documentary? An art installation?" My immediate response was, "You can't edit any of this out! We need to hear every single voice you've captured and make space for voices you could never capture manually."

I had just completed a number of digital projects for various art institutions that exposed me to some of the early work in interactive documentary, nonlinear storytelling, and data visualization.

A visitor explores a beta version of *Question Bridge*'s mobile app, Brooklyn Museum, 2012. Photograph by Yosra El-Essawy

Challenged by Hank's question, it hit me: this needs to be a website that people can navigate to discover different voices according to their curiosity. The site would provide visitors access to unedited question-and-answer exchanges in hopes of avoiding some of the censorship and framing biases of other ethnographic works. It would leverage emerging interface designs that allow users to artfully and seamlessly explore content. That night, the vision for *Question Bridge* as a transmedia project—with a film, art installation, website, and app—was conceived, and we started on a journey that took five years to complete.

As a mixed-race person, I grew up having to tick one box when filling out forms, which required me to select a false or limited

identity. It was like being forced to lie, to participate in a surreal reality. A reality that failed to recognize that my redheaded Irish mother provided fifty percent of my DNA, because I never marked *white*. From a very early age, I understood the history of the one-drop-of-blood rule that citizens of the United State of America were told to apply to the question of black identity. Although both the white and black communities in which I was raised—from the kids on the playground to the official registration papers at any government agency—accepted and perpetuated this lie, I knew in my heart that it was a deeply flawed model for defining and representing my identity.

As I grew older, I learned this limiting model didn't just fail the mixed folks, it actually failed all of us in one way or another. For example, once, while I was leading a diversity analysis for an arts institution, an Asian American employee initiated the interview by saying, "If you're here to get the Asian American perspective, you are in the wrong place. I don't have any Asian connection to that culture. But if you want the gay perspective, then we can talk." It was the first time I heard someone claim their authentic identity in a way that completely rejected the predetermined box they were expected to fill. He made explicit the reality of his identity that the demographic pie charts were too limited to reveal. It was liberating.

I'm sure old demographic models were created as a means to manage large sets of data with limited tools, but they were also con- structed to serve the needs of biased agendas. By 2009, we had new data-analysis tools that could handle exponentially more complex data sets than any twentieth-century tool—a democratization of the cre- ation and consumption of information—as well as an exploding num- ber of platforms that allowed individuals to express themselves. The time was ripe for innovating new models of representing the rich and dynamic nature of identity. *Question Bridge*, the first group-generated identity map for black men in America, is one experiment in designing and testing those new models. It attempts to give us a macro view of a complex system of identity, while simultaneously providing an intimate and human view into the minds and hearts of those who self-identify as part of that group. When describing the project, we would often say

Question Bridge is the "Twitter of healing dialogue within a demographic group, and the Google Earth of identity."

Five years after beginning the project, we have found that this methodology is uniquely effective at shattering the monochromatic stereotypes associated with an identity group, because both participants and viewers are free to recognize each person as an individual with limitless potential. Each participant can express agency, which releases him from the constraints of stereotypes. Audience members are able to break from static, twentieth-century thinking about identity, and adopt instead a multidimensional logic with which to process the waves of media-generated information they receive about black men. It's an exciting time.

1. Dr. Joy DeGruy is an internationally renowned researcher, educator, author, and presenter. She is the author of *Post Traumatic Slave Syndrome: America's Legacy of Enduring Injury and Healing* (2005) and *Post Traumatic Slave Syndrome: The Study Guide* (2009).

REFLECTION

BY DELROY LINDO

Are the lives of black people in America valued less than those of whites? Are young black male lives, in particular, valued even less? These salient questions were the center of the roiling national debate that emerged in the wake of the shooting death of an unarmed African American teenager, Michael Brown, by a white police officer in Ferguson, Missouri, in August 2014. The answer for many people, and in black communities throughout the nation, is a resounding yes. As the father of a young African American man child, I've followed this debate closely, with more than a little concern. Anyone paying attention knows that Brown's death follows a sickening historical pattern of the killing of unarmed young black men at the hands of armed assailants or the police. Michael Brown, Trayvon Martin, Jordan Davis, Oscar Grant, Eric Garner, Sean Bell, Amadou Diallo, and Tony Robinson are just some of the recent, high-profile examples. Additionally, there are scores of unarmed young black men killed by the police whose cases don't make the local news, much less receive national attention. These deaths point to a racial pathology, and indeed insanity, deeply embedded in American society.

How do black men living in America affirm their humanity and dignity in the face of these social dynamics? How does one raise one's son and maintain one's own sanity in the face of the widespread societal fear of black men, which seems to drive much

of the violence aimed at us? One can live one's life positively, in relationship with family, friends, and one's fellow human beings. One can also acknowledge and support endeavors that exhibit a profound humanity toward others, and which help illuminate the human condition.

Question Bridge: Black Males is one such endeavor. It demonstrates, in moving and profound ways, the complex nature of black masculinity. It exposes the depth and breadth of black male character and creativity, qualities that we aren't always given credit for, or given space to express.

Question Bridge: Black Males is a living, breathing entity. If the fundamental goal of art is to illuminate the human condition, the project and its creators succeed spectacularly. Its objective is to fundamentally redefine the understanding of black male identity in America, and create a paradigm shift in perception. In focusing on a very broad demographic of men, across economic, political, geographic, and generational lines, *Question Bridge's* audience is exposed to the equally broad set of emotions, thoughts, struggles, and fears existing within them. It dispels any notion of the black male monolith, presenting its subjects and their complexity, pain, frustrations, hopes, dreams, and aspirations. A number of the men had never been asked their opinions about anything in the past, which is telling and poignant in its own right.

Significantly, *Question Bridge* highlights the fears that a number of the participants articulate. Because of a generalized fear of black men that exists in America, and the ways it manifests against them, there is often little space for discussions of the fear that black men themselves may be feeling. In exerting time and energy allaying the fears of others, one is robbed of the opportunity to tend to one's own fears. Internalizing those fears, having no constructive alternative to do otherwise, results in unhealthy and destructive behaviors toward self and others. The violence we see, particularly among young black males, is certainly, on some level, a symptom of this. I say this not as an apology or validation for bad or violent behavior, but rather because of my own empirical thoughts and feelings, from my own

life and those of friends and colleagues. And so the *Question Bridge* respondents who speak of their fears resonate strongly with me. Two of *Question Bridge*'s creators, Chris Johnson and Hank Willis Thomas, I've come to know quite well. Their individual journeys have involved personal pain and tragedy. Tellingly, they have transformed that pain into socially and culturally relevant art.

I have the deepest respect and admiration for Chris's achievement. Out of tragedy, disaffection, even a cultural and personal sense of disenfranchisement—or maybe because of those things—Chris has transformed himself. Based on conversations with him, what seems notable is that, even as a young man of fourteen, he was attempting to understand his world, his community, and his circumstances in creative ways. There is a connection between the attempts of this fourteen-year-old child to understand his world, and that same person, forty years later, still striving to understand and illuminate it, for himself and for others. He has actively confronted and negotiated his own deep-seated fears, resulting in this personal transformation. Chris Johnson is as much a subject of *Question Bridge* as his participants are. He's told me the fundamental essence of the project is that it is a search for "meaningful truths than can be shared across the cultural divides that exist within the black community . . . [and has] as its sources . . . the goal of healing black hearts." I feel he refers to his own heart principally, as well as those of others. It is a sacred undertaking.

Chris readily acknowledges, though, the talents and contributions of his collaborators. Though *Question Bridge* is certainly his brainchild, its development and evolution have been a joint creation, with Hank Willis Thomas, Bayeté Ross Smith, and Kamal Sinclair. The gifted photographer and artist Hank Willis Thomas has been especially involved in the development and evolution of the project since its inception. Hank's work with *Question Bridge*, and our longstanding friendship, led to my own involvement.

Hank, with his enormous creative energy and vision, is the person who challenged Chris to expand his original idea into what *Question Bridge* has become. Consequently, Chris talks of experiencing a

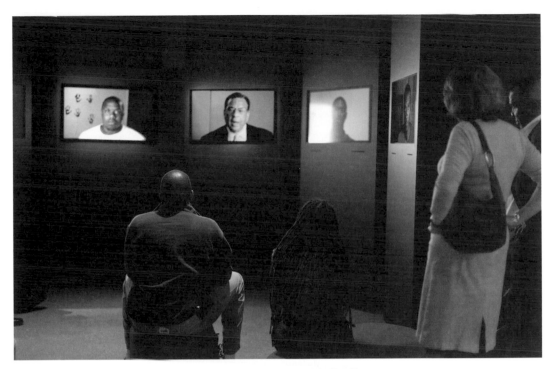

Installation view, courtesy the Oakland Museum of California, 2012. Photograph by Yoni Klein

personal transformation, as the project has evolved. As a former photography student of Chris's, Hank speaks of him as a mentor. Their relationship illuminates their work in stunning ways.

Hank lives his life very much in the tradition of any dedicated artist, as a seeker, trying, simply, to use his work to understand and illuminate life. He's spoken to me of having twice seen portions of Chris's 1996 version of *Question Bridge*. In the aftermath of losing a beloved cousin to gun violence, he continued creatively exploring "issues related to African American men . . . and the complexities and ways they've been represented . . . and the impact popular culture and [these] representations have on African Americans." After receiving a New Media grant in 2007 from the organization that became the Tribeca Film Institute, and sensing the potential power of black people asking and answering each other's questions, he told me that

he'd "struggled consistently with getting to the root of black male identity . . . as a black man myself, I thought it would be pretty easy to sort that out, but in reality it was very, very difficult. So what I chose to do is to ask Chris if we could use his question-bridge format to apply it to a new idea which became *Question Bridge: Black Males.* I—we—had the implicit idea of trying to show that there's as much diversity within black males—there's as much diversity within any demographic as there is outside of it." *Question Bridge*, among many other things, is part of a continuum for Hank, examining black men in general, and specifically violence among black men. The loss of his cousin Songha has become a part of that construct, actively transforming his personal tragedy into a potent creative endeavor.

Acknowledging the learning curve involved in conducting the project's initial interviews, Hank nevertheless demonstrated a creative nimbleness: "I thought I would be able to see a black man . . . assess him, assess the questions I could ask . . . but I realized I was limiting the range of ways black men could be and see themselves and represent themselves." Hank, Chris, and Bayeté were astute enough to quickly recognize the intrinsic value in having the various *Question Bridge* respondents express their own feelings in their own words, and they adapted the process accordingly. Hank describes it as "a really healing and enlightening experience for [myself], Chris, and Bayeté—being flies on the wall as this conversation took place. It was really beautiful to watch these total strangers open up to us in ways that men normally just don't." Speaking of the *Question Bridge* community forums, he remarks that they "feel almost like church." And goes on to say that African American men have an "intergenerational healing circle and conversation in front of a live audience . . . and most of the men are strangers—and not necessarily men who you would ordinarily expect to go listen to at a museum, or institution . . . people can come and [have] their minds blown by this range of individuals—who are defined under the mast head of black male. For me, *Question Bridge* has been incredibly healing."

All four of the project's principals demonstrate equally strong commitments to the overall mission. Hank speaks of Kamal Sinclair's

dedication to creating and developing the educational component of *Question Bridge*'s programming, and her vision for how the programming could be applied to various educational curriculums. The program has grown, positively impacting the lives of a range of people. And having *Question Bridge* programming specifically connect with Youth is a particular objective for Bayeté Ross Smith.

It's clear that *Question Bridge: Black Males* is very much the result of a collaboration between all four artists. In Hank's words, "None of us could have done this without any of the others . . . so that's really the beauty of it."

Ultimately, *Question Bridge* is much larger than any individual. It's an elemental project and process, enormous in its scope and potential. One is moved, therefore, to try and engage the project on its own terms. At this point, with its community forums, educational curriculums, and significant web presence; the impact and "footprint" of *Question Bridge* has extended far beyond its initial incarnation. It has both the potential to elicit change across society and to be an instrument of transformation and healing. It can help heal all of us, because it is about all of us. As audience members, we are moved, surprised, and humbled by the participants' responses, so we all have the capability to examining ourselves and to marvel at, and grow from, our own responses to the work.

It is said that in the specific is the universal. The potential of a project like *Question Bridge: Black Males* is in the way it pushes its viewers to examine themselves, the way it asks them to remain open to changing their perceptions of their fellow human beings. In this way, the work can create the real and true paradigm shift its creators desire, for society and indeed for America and beyond. As one viewer observed, "Its message overrides gender, race, and socioeconomic lines, and connects the viewer with a real face, a real heart, mind, and soul. So that across a great divide, I, a middle-class, white, middle-aged woman could relate and feel compassion for a former crack dealer in prison, and perceive his keen intelligence and worth. I was so moved. It is truly a national treasure, and should be seen by many more people."

#BLACKLIVESMATTER

SHIFTING PERSPECTIVES AND CHANGING THE NARRATIVES AROUND AMERICA'S BLACK MEN AND BOYS

BY RASHID SHABAZZ

In 2008, the Open Society Foundations launched the Campaign for Black Male Achievement (CBMA) in an effort to address the continued exclusion of black men and boys from civic, social, political, and economic life in America. At the heart of our efforts at the foundation was the use of stories, narratives, and images to help ensure that black men and boys were at the center of philanthropic, political, and public discourse. The fact that the launch of the campaign aligned with the ascendance of President Barack Obama to the White House affirmed for Shawn Dove—the visionary behind CBMA—and me that we had to seize this moment.

In many ways, we have. Since the launch of the campaign, we have helped to drive increased focus on and investment in the participation of black men and boys in philanthropy and government. Today, over forty foundations have committed to improving the life outcomes of boys and men of color, a significant increase from the handful of foundations engaged in this work seven years ago. And more recently, President Obama announced the My Brother's Keeper initiative, which was in large part fueled by our investments in building and growing the interest in black male achievement.

It was during the early phase of the campaign, as we began to define a field of black male achievement and make exploratory investments in strategic communications to help drive a more

accurate portrayal of black men and boys, that we had the opportunity to meet visual artists Hank Willis Thomas and Chris Johnson, both collaborators on the *Question Bridge: Black Males* project. Hank and Chris came to our offices and shared their vision of creating an art exhibition and online platform that would help create both an intra-racial and interracial dialogue around the humanity of black men and boys in America. At the time, we had begun investing in a few film projects—including *American Promise* (2013) by Joe Brewster and Michele Stephenson—and supporting the advocacy efforts of groups like Color of Change, which worked to hold media and the entertainment industry accountable for their portrayals of black men, boys, women, and girls. We had also begun to support BMe Community and the Perception Institute, which focuses on addressing how implicit bias impacts the life chances of black men and boys. Given our involvement with these initiatives, a project like *Question Bridge: Black Males* was really a no-brainer for us, since investing in it would help advance CBMA's strategy of ensuring a more asset-based narrative around black men and boys as a way to change hearts and minds among black men, as well as all Americans.

Creating an online space for black men and boys to share their most intimate questions and answers seemed to be one possible way to begin chipping away at the burden of negative perceptions that rests on their shoulders. As one of the early investors in the project, I can say without hesitation that *Question Bridge: Black Males* is one of the most critical and promising efforts we have supported to date. The opening of the exhibition at the Brooklyn Museum broke attendance records, and the project's ambitious goal of engaging two hundred thousand people through its online platform does not seem like a stretch when you consider that in three short years, the project has been seen and touched by more than five hundred thousand people from all walks of life.

Yet despite this progress, the work ahead is great. More than sixty years since *Brown v. Board of Education*, and 150 years since the Emancipation Proclamation, our country is once again wrestling with the question of whether the lives of black men and women

matter or hold the same value as the lives of others in American society. As I write this, a new generation of advocates advancing the cause of civil and human rights for African Americans and all Americans concerned with fairness and justice have come together under the rallying cry #BlackLivesMatter. The very concept of #BlackLivesMatter suggests two obvious realities. The first affirms what we know to be true: that indeed, black lives do matter. The second, more troubling reality is that some may feel and act upon a belief that black lives may not matter. In his book *Homo Sacer: Sovereign Power and Bare Life* (1995), philosopher Giorgio Agamben explores "bare life"—a life deemed unworthy of living or undeserving of life. The Latin phrase *homo sacer* was defined in Roman legal terms as someone who could be killed without the killer being regarded as a murderer. Despite the obvious contributions black lives have made to this country and the world (free labor, music, arts, culture, sports, entertainment, education, science, technology, and so forth), the racist stereotypes of black men and women shaped by the media, and a history of dehumanizing imagery—black men as sambos or Uncle Toms; black women as mammies or jezebels— has affirmed for many that black lives simply may not matter, or that black people can be killed without the killers facing any consequences. In many ways black life in America parallels what Primo Levi described in his book *The Drowned and the Saved* (1986). In describing how Nazis were conditioned and primed to carry out the execution of Jews in concentration camps, Levi writes that "before dying the victim must be degraded, so that the murderer will be less burdened by guilt. This is an explanation not devoid of logic but it shouts to heaven: it is the sole usefulness of useless violence."

Today, the caricature and stereotype that degrades black men and justifies their killing is based on the music they may listen to, the hoodie they may sport, or simply how far their pants may sag: in other words, the thug. For some the word *thug* has become synonymous with the bitter and hurtful word *nigger*. Yet unlike nigger, thug has become more politically acceptable and palatable among conservative and liberal pundits alike, who try to address the implicit

The education room for *Question Bridge: Black Males*, Project Row Houses, Houston, 2013. Photograph by William Sylvester

bias that affirms the unjustifiable fear that law enforcement and all of us have of black men and boys. We all carry bias of some kind against black men, even those of us who are black men ourselves.

Our sons, our fathers, our uncles, and our brothers are to a large degree seen as threats due to the way black men and boys are portrayed in the media. As the Opportunity Agenda documents in its report *Opportunity for Black Men and Boys: Public Opinion, Media Depictions, and Media Consumption* (2011):

> Among the many factors that influence the opportunities and achievements of black men and boys are public perceptions and attitudes toward them as a group, and their own self-perceptions as

well. Research and experience show that expectations and biases on the part of potential employers, teachers, health care providers, police officers, and other stakeholders influence the life outcomes of millions of black males, just as their own self-esteem, identity, and sense of empowerment affect their ability to achieve under difficult circumstances.

The murders of Trayvon Martin, Jordan Davis, Michael Brown, Tamir Rice, Eric Garner, John Crawford, Ezell Ford, and the countless others whose names we may or may not know, at the hands either of those who are supposed to serve and protect us or vigilante citizens who feel it is their right to stand their ground, are all rooted in the history of portrayals of black men as brutes and thugs. Black lives are bare lives, fully exposed for the public's spectacle and gaze.

There should be no wonder why so many engaged in protest die-ins are chanting the words "I can't breathe" or "black lives matter." The fact that we must even chant these words should suggest that something has fundamentally gone awry in our country. The fact that African American men and women continue to be incarcerated at higher rates than their white peers for crimes committed at equal or lower frequency; the fact that there remains a growing wealth gap between black and white, with the black middle class shrinking more each day; the fact that our country continues to witness the wanton killings of black men and women (Renisha McBride, Aiyana Jones) without due justice, while their murderers have found protection under the law—all this suggests that the lives of black men and women continue to be devalued to the point that one may wonder how far we have actually come since the Three-Fifths Compromise.

While the prospects of creating empathy for black men and boys may seem to be at their bleakest point in recent history, I personally believe and am hopeful that Question Bridge, with its images and stories that affirm the value of black male lives, can help create a new paradigm in which we are no longer simply victims or villains, athletes or entertainers or thugs, but can be seen in our full humanity. I also believe that, as in the civil rights movement and the black power movement that followed—in which black male identity

was affirmed in some cases to the detriment of the advancement of black women and girls—we are once again on the cusp of a social movement that could not only transform the ways black men and boys are viewed, but could also challenge the ways in which flawed and narrow definitions of masculinity and patriarchy have continued to keep white supremacy and racial and gender inferiority alive, despite the fact that science has shown, beside the complexion of our skin, we are indeed each other's brothers and sisters.

The Campaign for Black Male Achievement remains a champion and supporter of *Question Bridge: Black Males* because its potential to become a vehicle that redefines black male identity has yet to be fully realized. We also stay committed because, as Thelma Golden writes in *Black Male: Representations of Masculinity in Contemporary American Art* (1994), "The challenge of representing and questioning the image of the black male is great. Black masculinity suffers not just from overrepresentation, but oversimplification, demonization, and (at times) utter incomprehension." *Question Bridge: Black Males* has taken up the challenge of addressing the question of black male identity, and has in many ways placed us on the path to reaffirming our humanity and rendering us no longer invisible.

SELECTED RESOURCES

100 Black Men of America, Inc.
Implements programs designed to improve the quality of life for African Americans and other minorities, and provides resources for youth development.

2025 Network for Black Men and Boys
Encourages collaboration for the development and empowerment of African American men and boys. Website includes a map-driven database for finding organizations.

All Star Code
A nonprofit initiative that prepares qualified young men of color for full-time employment in the technology industry.

Black Boys Rock
A movement that seeks positive interaction from people of all races with an emphasis on promoting awareness about the strength of black boys and men.

Black FreeThinkers
A Blog Talk Radio program that hosts discussions on a range of topics, from art to automotives, with a focus on the black community.

Black Life Matters
An online forum intended to build connections between black people and our allies to fight anti-black racism.

Black Male Development Symposium
Provides a forum to present practical strategies and solutions to improve the quality of life for African American males and their communities.

Black Male Identity Project
Aims to stimulate community-wide dialogue, art making, and sharing of images and ideas to create a more authentic black male identity.

Black Male Teacher Network
Mindful that less than two percent of teachers in the United States are black males, this nonprofit supports educators in schools nationwide.

The Black Man Can
A website that features positive news stories about black males and highlights passion-filled, successful individuals in the "League of Extraordinary Black Men."

The Black Star Project: Million Father March
Since the march began in 2004, black fathers, relatives, and significant male caregivers asked to take their children to their first day of school.

Black Studies Online
The first and only online educational program dedicated to providing a variety of scholarly courses to members of the general public interested in exploring the history, culture, and contemporary experiences of black people.

Black Youth Project 100
An activist, member-based organization of black eighteen- to thirty-five-year-olds dedicated to creating justice and freedom for all black people.

BMAFunders
Strives to facilitate engagement, catalyze collaboration, and promote strategic decision making in the field of black male achievement.

BMe Community
A real-world social network for building more caring, prosperous communities, inspired by black men who lead in matters such as economic opportunity and violence prevention.

Brotherhood Crusade
An institution that raises funds and resources from within the community and distributes those funds directly back.

The Brothers' Network
Engages men of the African diaspora in intellectual and artistic discourse to amplify a new narrative about their contributions in the performing and visual arts.

Call Me MISTER
Identifies promising students from underserved communities and provides them with tuition assistance and academic and social support when they enroll in education programs.

The Campaign for Black Male Achievement
A national membership network that seeks to ensure the growth, sustainability, and impact of leaders and organizations committed to improving the life outcomes of black men and boys.

CBMA.Catchafire.org
Helps link professionals to short-term, skills-based volunteer opportunities with nonprofits serving black males.

Cities United
A national movement focused on eliminating the violence in American cities related to African American men and boys.

City University of New York: Black Male Initiative
Hosts speakers and conferences, and establishes projects on CUNY's campuses to support the enrollment and retention of students from underrepresented groups.

Coalition of Schools Educating Boys of Color
A national organization of school leaders focused on improving success in school among boys and young men of color.

College Bound Brotherhood
Seeks to expand the number of young black men who are prepared for a college education.

Concerned Black Men
Strives to fill the void of positive black male role models.

The Family Partnership: BeMore Campaign
Engages African American men to teach young men and boys about healthy relationships, and aims to break the cycle of domestic violence.

Game Changers Project
A national media-fellowship program for emerging black filmmakers, in partnership with community-based organizations dedicated to improving outcomes for males of color.

Heinz Endowments: African American Men and Boys Initiative
Focuses its granting on strengthening economic opportunities, education, gender identity and character development, public communications, and advocacy for African American males.

Life Pieces to Masterpieces
Engages African American young men and boys in Washington, D.C.'s most challenging neighborhoods, providing after-school, weekend, and summer programs.

Mentoring Brothers in Action
A movement led by Big Brothers, Big Sisters, and the nation's three largest African American fraternities. It aims to engage more African American men in fraternal, social, faith-based, and professional organizations.

My Brother's Keeper
The White House administration is taking important steps to provide young people with mentoring and support networks, and equip them with the necessary skills to gain employment or higher education and achieve better economic status.

The Oakland Unified School District's Office of African American Male Achievement
Aims to create the systems, structures, and spaces that guarantee success for all African American male students across the Oakland Unified School District in California.

The Opportunity Agenda
Conducts research studies exploring greater opportunities for black men and boys through a lens of public opinion, media depiction, and media consumption.

Perception Institute
Consortium of mind-science researchers, educators, and social-justice advocates that develops strategies to reduce racial bias and anxiety.

Race Forward
Advances racial justice through research, media, and practice.

The Root: BrotherSpeak
The *Washington Post*, in cooperation with the Maynard Institute for Journalism Education, explores the experiences of black men in America in a three-part video series.

Schott Foundation for Public Education
Produces original reports, including a fifty-state "report card" on the high-school graduation rates of black male students.

Sons & Brothers
An alliance of local and national organizations, communities, and corporations united to help America's young men of color reach their full potential in school, work, and life.

Student African American Brotherhood
A nationwide network of student-run chapters that increases the number of African American and Latino men who graduate from college.

Visible Men Academy
Strives to deliver a high-quality educational experience that meets the specific needs of at-risk elementary- and middle-school-aged boys.

White House Initiative on Educational Excellence for African Americans
A cross-agency effort aimed at identifying evidence-based practices that improve student achievement and developing a national network that shares these practices in bettering the educational outcomes of African Americans.

#YESWECODE
This initiative targets low-opportunity youth and provides them with the necessary resources and tools to become world-class computer programmers.

BIOS

AMBASSADOR ANDREW YOUNG is a diplomat, educator, minister, and civil-rights activist. As the executive director of the Southern Christian Leadership Conference, he helped propose the Civil Rights Act of 1964 and the Voting Rights Act of 1965. In 1972, Young was elected to the United States Congress as a representative of Georgia. During his time in Congress, President Jimmy Carter selected him to serve as the U.S. ambassador to the United Nations. In 1981, Young was elected mayor of Atlanta and served for eight years. In 2003, he created the Andrew Young Foundation to support and promote education, health, leadership, and human rights in the United States, Africa, and the Caribbean.

JESSE WILLIAMS is an actor, social-justice activist, and former teacher. He is a member of the board of directors at the Advancement Project, a think tank and advocacy group, and founder of the production company farWord Inc. He has written extensively about a range of issues, including police terrorism, hunger, and predatory media practices for CNN and the *Huffington Post*, and has also addressed related matters as a guest on various MSNBC, NPR, and CNN programs. Williams entered the national spotlight as Dr. Jackson Avery in ABC's *Grey's Anatomy*. His feature credits include *They Die By Dawn* (2013), *Lee Daniels' The Butler* (2013), *The Cabin in the Woods* (2012), *Brooklyn's Finest* (2009), and *The Sisterhood of the Traveling Pants 2* (2008).

CHRIS JOHNSON is an Oakland-based artist and professor of photography at California College of the Arts. Previously he served as the president of SF Camerawork, director of the Mother Jones International Fund for Documentary Photography, and chair of City of Oakland Cultural Affairs Commission. His book *The Practical Zone System for Film and Digital Photography* (1999) is currently in its fourth printing.

HANK WILLIS THOMAS is a photo-conceptual artist working primarily with themes related to identity, history, and popular culture. His work is included in numerous public collections, including the Museum of Modern Art, Brooklyn Museum, and Solomon R. Guggenheim Museum. Aperture published Thomas's first monograph, *Pitch Blackness*, in 2008. He was recently appointed to the Public Design Commission of the City of New York. He is represented by Jack Shainman Gallery, New York, and Goodman Gallery, South Africa.

BAYETÉ ROSS SMITH is a multimedia artist and educator based in Harlem, New York. His work has been shown at such institutions as the Brooklyn Museum, San Francisco Arts Commission, Utah Museum of Contemporary Art, and Goethe Institut, Ghana. He is currently the associate program director for the Kings Against Violence Initiative, a violence-prevention non-profit organization.

KAMAL SINCLAIR is codirector of Sundance Institute's New Frontier Story Lab. Sinclair is a transmedia producer, theatrical director, community arts leader, and multidisciplinary artist. She was a producer at 42 Entertainment, and performed in various off-Broadway theater productions, including *STOMP*.

DELROY LINDO is an award-winning actor, theater director, and activist. Lindo has had roles in films such as *Heist* (2001), *The Cider House Rules* (1999), *Crooklyn* (1994), and *Malcolm X* (1992). Lindo earned a Tony Award nomination for his starring role in *"Master Harold" . . . and the Boys* on Broadway. Lindo has also worked in television, off-Broadway, and extensively in regional theaters throughout the United States and Canada. He directed *Joe Turner's Come and Gone* at Berkeley Repertory Theatre, California (2008).

RASHID SHABAZZ is the chief operating officer of the Campaign for Black Male Achievement (CBMA). He has over seventeen years of experience as a grassroots media and communications organizer, and has also served as a contributing writer to several publications. Shabazz holds a BA in English from George Mason University, an MA in African studies from Yale University, and an MS from the Columbia University Graduate School of Journalism. While working with CBMA, Shabazz has contributed to the New York City Young Men's Initiative and the documentary *American Promise* (2013).

DEBORAH WILLIS, PhD, is professor and chair of the department of photography and imaging at Tisch School of the Arts, New York University. She has been a Richard D. Cohen Fellow of African and African American Art History at the Hutchins Center, Harvard University (2014), a Guggenheim Fellow (2005), a Fletcher Fellow (2005), and a MacArthur Fellow (2000). Willis received the NAACP Image Award in 2014 for her coauthored book *Envisioning Emancipation: Black Americans and the End of Slavery* (2013). Her other notable publications include *Black Venus 2010: They Called Her "Hottentot"* (2010), *Posing Beauty: African American Images from the 1890s to the Present* (2009), the award-winning *Michelle Obama: The First Lady in Photographs* (2009), *The Black Female Body: A Photographic History* (2002), and *Reflections in Black: A History of Black Photographers, 1840 to the Present* (2002).

NATASHA L. LOGAN is a multimedia arts producer and independent curator who has worked with a broad range of artists to create fine art, transmedia, and film projects. As a producer for *Question Bridge*, she led strategic planning, exhibition management, operations, and the creation of new interactive platforms. Prior to her production practice, Logan served as the assistant director of career development at New York University's Tisch School of the Arts. She has curated independent exhibitions for artists in the United States and the United Kingdom. She graduated with a BA in English literature and African American studies from the University of Virginia.

ACKNOWLEDGMENTS

With much gratitude to the following people and institutions for their support, advice, and assistance in making this book possible: the Bay Area Video Coalition, Open Society Foundations, Ford Foundation, California Endowment, Tribeca Film Institute New Media Fund, LEF Foundation, Center for Cultural Innovation, Nathan Cummings Foundation, California College of the Arts, and Sundance Institute and its New Frontier Story Lab.

The following institutions graciously offered their spaces for a viewing public to witness the project: the Brooklyn Museum; Oakland Museum of California; Utah Museum of Contemporary Art, Salt Lake City; Chastain Arts Center, Atlanta; Jack Shainman Gallery, New York; Exploratorium, San Francisco; Birmingham Museum of Art, Alabama; Project Row Houses, Houston; Corcoran Gallery of Art, Washington, D.C.; Fabric Workshop and Museum, Philadelphia; Winthrop University, Rock Hill, SC; Rochester Contemporary Art Center, NY; San Diego African American Museum of Fine Arts; Community Folk Art Center at Syracuse University, NY; Harvey B. Gantt Center for African American Arts+Culture, Charlotte, NC; California African American Museum, Los Angeles; DuSable Museum of African American History, Chicago; Schomburg Center for Research in Black Culture, New York; Papillon Gallery, Los Angeles; Cleveland Museum of Art; Photographic Center Northwest, Seattle; Milwaukee Art Museum; Juxtaposition Arts, Minneapolis; Sumter County Gallery of Art, SC; Missouri History Museum, St. Louis; Catharine Clark Gallery, San Francisco; Zora Neale Hurston National Museum of Fine Arts, Eatonville, FL; Bloomfield College, NJ; Sheffield Doc/Fest, United Kingdom; Los Angeles Film Festival; YMCA of Greater Hartford and Central Connecticut Coast YMCA, with help from the Amistad Center for Art & Culture at the Wadsworth Athenaeum Museum of Art, Hartford, CT; and the New Frontier exhibition at the Sundance Film Festival, Park City, UT.

We owe an enormous debt of gratitude to the participants who freely shared their stories on screen, and we equally extend our heartfelt thanks to the essayists who contributed on the printed page, including Ambassador Andrew Young; artists and activists Delroy Lindo and Jesse Williams; the creators of Question Bridge: Black Males, Chris Johnson, Hank Willis Thomas, Kamal Sinclair, and Bayeté Ross Smith; and Rashid Shabazz.

We learned that friends are everywhere around the globe, and because of their respect for our work we would like to thank the following individuals: Michelle Satter, Arnold Lehman, Charles Desmaris, Rene De Guzman, Wendy Levy, Jinan Sumler, Michael Lantz, Suzanne Lacy, Dr. Joy Angela DeGruy, Gloria Joyce Johnson, Angela Denise Robb, Karen Lowe, Rick Lowe, Claudine Brown, Pamela Winfrey, Travis Somerville, Catherine Clark, Linda Shearer, Kippy Stroud, David Taylor, Charmaine Jefferson, Jack Shainman, Claude Simard, Lisa Sutcliffe, Olivia White, W. Frank Mitchell, Shari Frilot, Cara Mertes, Lance Singletary, Tricia Laughlin

Bloom, Michelle Papillon, Teka Selman, Sophie Sanders, Stephanie Greene, Karen Derksen, Bleu Cease, Gaidi Finnie, Dr. Kheli Willetts, Vida Brown, Charles Bethea, Dr. Carol Adams, Sheri Walters, Auggie Napoli, Barbara Tannenbaum, Fred and Laura Bidwell, Michelle Dunn Marsh, Gail Andrews, Brody Roberts, Nate Young, Frank White, MK Stallings, Thomas Sleet, Halima Taha, Chris Connolly, Jane Saks, Corey Baylor, Isolde Breilmaier, Christine Alicino, Casey Alicino Racquel Chevremont, Daniel Cunningham, Patrick Amsellem, Takaki Okada, Shawn Dove, Romi Crawford and Damien McKnight, Kevin and Karen Johnson, Michael Liburd, Jonathan Poullard, Cheryl Riley, Erin Texeria, Mickalene Thomas, Jun Lee, Camille Love, Jabari Mahiri, Alexis McGill-Johnson, James O'Brien, Jennifer Samuel, Gerald and Dorothy Sinclair, Adam Forrest, Steven Cantor, Kellie Jones, Tony Dreannan, Kiser Haydar Barnes, Coby Kennedy, Takaaki Okada, Kambui Olujimi, Tim Jones, Mecca Brooks, Jamal Johnson, Claudia Peña, Medea Brooks, Yvonne Brooks, Keith Calhoun, Chandra McCormick, Melvina Lathan, Sharon Howard, Mei Tei Sing Smith, Syda Taylor, Leslie Willis Lowry, Hank Thomas, Sr., Kalia Brooks, Maurine Knighton, Lonnie Graham, Aaron Koblin, Noland Walker, Keri Putnam, Guido Maus, Jamilah King, Hadeel Ibrahim, Charles Desmarais, Nashormeh and Damiri Lindo, Marisa Katz, Paul Moakley, Vanessa Ross, Rodney Jones II, Ruth Willis, Alazeem Hameed, James Talley, Jr., Charles Young, Leon Butler, JaMarquis Weaver, and Maurice Kirkpatrick.

We appreciate those whose contributed countless hours towards the advancement of the project: Will Sylvester, Rosa White, Jon Vidar, Sarah Lowe, Aryn Drake Lee Williams, Shelby Leoning, Raquel de Anda, Omolara McAllister Williams, Gervais Marsh, Christine Wong Yap,

Ryan Alexiev, Frank Hooker, Jr., Cinque Northern, Aqeela Sherrills, and Jamila Hooker.

We thank our education team for helping us redefine how this project could be used to educate the public, especially education directors Samara Gaev and LaShaune Fitch, Chris Chatmon, Jennifer DiFiglia, Malika Bibbs, Derek Jones, Byam Terry, Ben Honoroff, Principal Piper, Corey Alexander, Talib Brown, Howard Buford, Candice Douglas, James O'Brien, Ron Walker, Ray Singer, Lacy Austin, Monica Protho, Morgan Gariss, Michael Simanga, Carlton Rutner, John Hope Bryant, Susan Taylor, March Philpart, and Naomi Abraham.

We owe endless thanks to Darren Walker, Luis Ubiñas, Roberta Uno, Hilary Pennington, Orlando Bagwell, and Sharon La Cruise of the Ford Foundation; our advisory board, including Rachelle V. Browne, Manthia Diawara, Amina J. Dickerson, Howard Dodson, Jr., Radiah Harper, Thomas Allen Harris, Caran Hartsfield, Khalil Gibran Muhammad, PhD, Seith Mann, Ron Platt, and Kathe Sandler.

Special thanks to our impressive Scholarship Steering Committee: Dr. Lonnie Bunch; M. K. Asante, Jr., PhD; Dr. Joy Angela DeGruy; Robeson Frazier, PhD; Professor Robert Hill; Robin D. G. Kelley, PhD; Leslie King Hammond, PhD; Guthrie Ramsey, PhD; Christopher Robbins, PhD; and Paul C. Taylor, PhD.

And last, but most certainly not least, we thank all of our BAVC supporters and 616 Kickstarter backers for accepting the challenge; and Lesley Martin, Chris Boot, Samantha Marlow, and Albert James Ignacio for guiding this project to publication.

—Natasha L. Logan and Deborah Willis, coeditors

Question Bridge
Black Males in America
Edited by Deborah Willis and Natasha L. Logan
Foreword by Ambassador Andrew Young
Preface by Jesse Williams
Featuring contributions by Chris Johnson, Hank Willis Thomas, Bayeté Ross Smith, Kamal Sinclair, Delroy Lindo, and Rashid Shabazz

Project Editor: Samantha Marlow
Designer: Albert James Ignacio
Production: Matthew Harvey
Senior Text Editor: Susan Ciccotti
Copy Editor: Amelia Schonbek
Proofreader: Madeline Coleman
Production Assistant: Luke Chase
Work Scholars: Karin Kuroda and Lauren Zallo

Additional staff of the Aperture book program includes: Chris Boot, Executive Director; Sarah McNear, Deputy Director; Lesley A. Martin, Creative Director; Kellie McLaughlin, Director of Sales and Marketing; Amelia Lang, Managing Editor

This book was made possible, in part, with generous support from the Open Society Foundations.

Question Bridge: Black Males in America is copublished by the Campaign for Black Male Achievement (CBMA), a national membership network that seeks to ensure the growth, sustainability, and impact of leaders and organizations committed to improving the life outcomes of black men and boys. CBMA is a growing network that currently includes more than 4,300 individuals representing 2,456 organizations and programs across the country.

✕ CBMA

Question Bridge: Black Males is a fiscally sponsored project of the Bay Area Video Coalition (a 501c3 not-for-profit organization), and supported in part by a grant from the Open Society Foundations' Campaign for Black Male Achievement, Ford Foundation, California Endowment, Tribeca Film Institute New Media Fund, LEF Foundation, Center for Cultural Innovation, Nathan Cummings Foundation, and California College of the Arts. The project was supported by the Sundance Institute's New Frontier Story Lab.

First edition
Printed by Artron in China
10 9 8 7 6 5 4 3 2 1

Library of Congress Cataloging-in-Publication Data
Question bridge : Black males in America / foreword by Andrew Young ; preface by Jesse Williams ; featuring contributions by Chris Johnson, Hank Willis Thomas, Bayete Ross Smith, Kamal Sinclair, and Delroy Lindo ; afterword by Rashid Shabazz ; edited by Deborah Willis and Natasha Logan. — 1st edition.
 pages cm
 Includes bibliographical references.
 ISBN 978-1-59711-335-9 (pbk. : alk. paper)
1. African American men--Race identity. 2. African American men--Attitudes. 3. African Americans--Social conditions--21st century. 4. African American men--Pictorial works. 5. Video installations (Art) I. Johnson, Chris, 1948- II. Willis, Deborah, 1948- editor. III. Logan, Natasha, editor. IV. Title: Black males in America.
 E185.625.Q42 2015
 305.38'896073--dc23

 2015020714

Aperture Foundation books are distributed in the U.S. and Canada by:
ARTBOOK/D.A.P.
155 Sixth Avenue, 2nd Floor
New York, N.Y. 10013
Phone: (212) 627-1999
Fax: (212) 627-9484
E-mail: orders@dapinc.com
www.artbook.com

Aperture Foundation books are distributed worldwide, excluding the U.S. and Canada, by:
Thames & Hudson Ltd.
181A High Holborn
London WC1V 7QX
United Kingdom
Phone: + 44 20 7845 5000
Fax: + 44 20 7845 5055
E-mail: sales@thamesandhudson.co.uk
www.thamesandhudson.com

aperture

Aperture Foundation
547 West 27th Street, 4th Floor
New York, N.Y. 10001
www.aperture.org

Aperture, a not-for-profit foundation, connects the photo community and its audiences with the most inspiring work, the sharpest ideas, and with each other—in print, in person, and online.